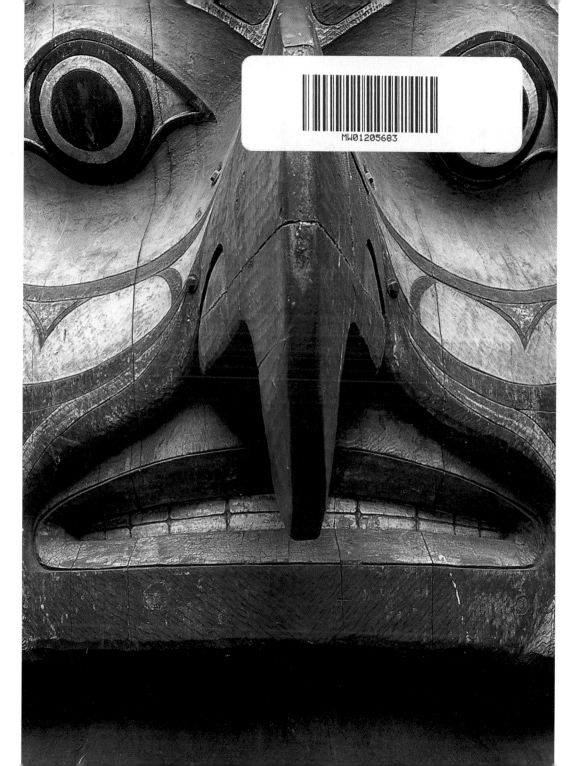

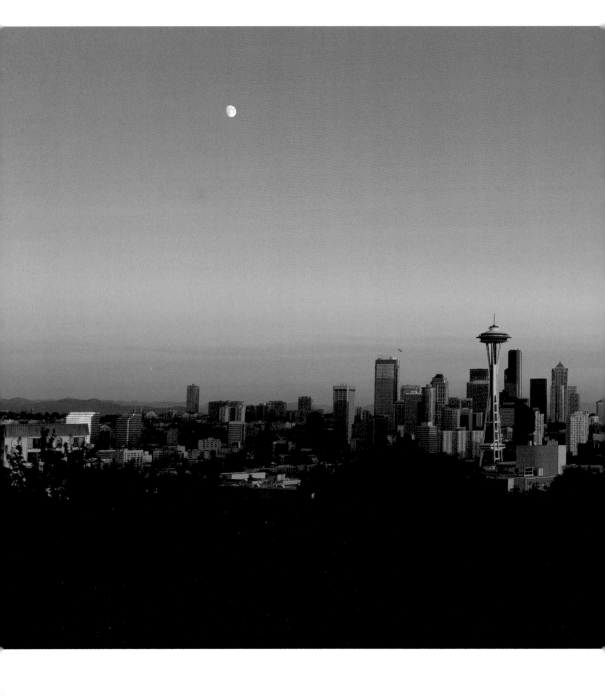

SEATTLE

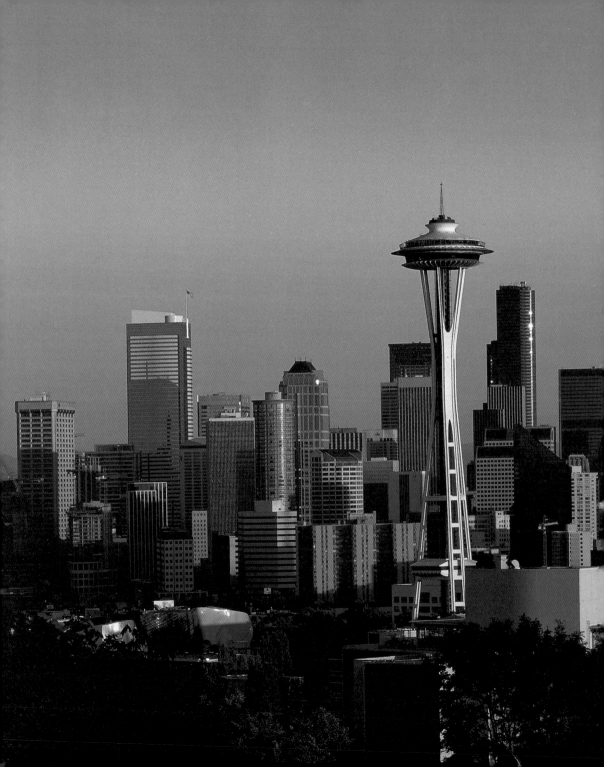

SEATTLE

PHOTOGRAPHY BY PAUL SOUDERS

Essays by Bill Radke

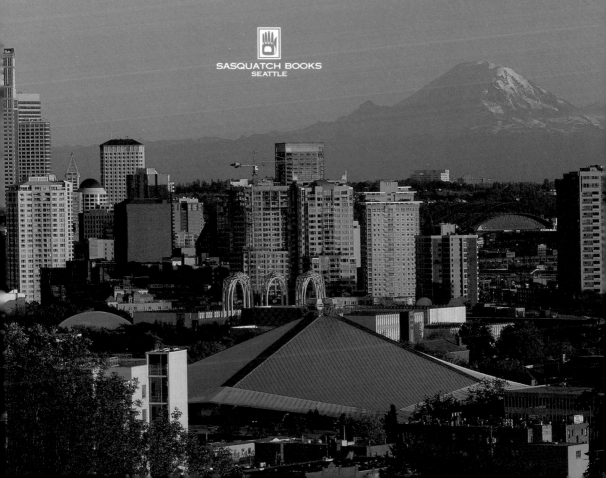

SASQUATCH BOOKS
SEATTLE

Printed in Singapore by Star Standard Industries Pte Ltd.
Published by Sasquatch Books
Distributed by Publishers Group West
09 08 07 06 05 04 03 6 5 4 3 2 1

Cover/Interior design: Stewart A. Williams

Library of Congress Cataloging in Publication Data
Souders, Paul.
 Seattle / [photographs by] Paul Souders ; essays by Bill Radke.
 p. cm.
 ISBN 1-57061-276-5
 1. Seattle (Wash.)--Pictorial works. 2. Seattle (Wash.)--Description and travel. I.
 Radke, Bill. II. Title.

 F899.S443S66 2003
 979.7'772'00222--dc21

Sasquatch Books
119 South Main Street, Suite 400
Seattle, Washington 98104
(206) 467-4300
www.sasquatchbooks.com
books@sasquatchbooks.com

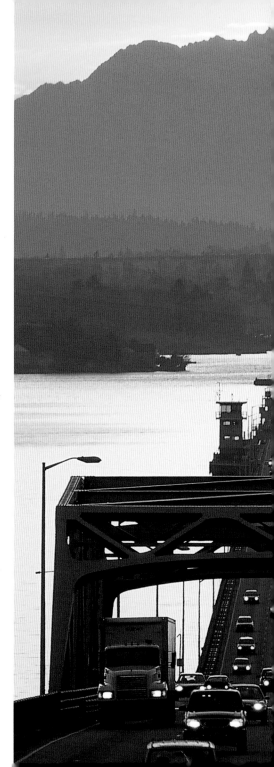

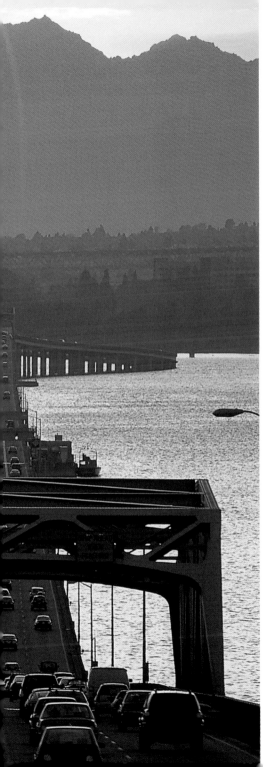

Page i: Totem pole in Pioneer Square.

Pages ii-iii: The Seattle skyline, looking south from Kerry Park atop Queen Anne Hill.

Pages iv-v: Lacey V. Murrow Floating Bridge crossing Lake Washington.

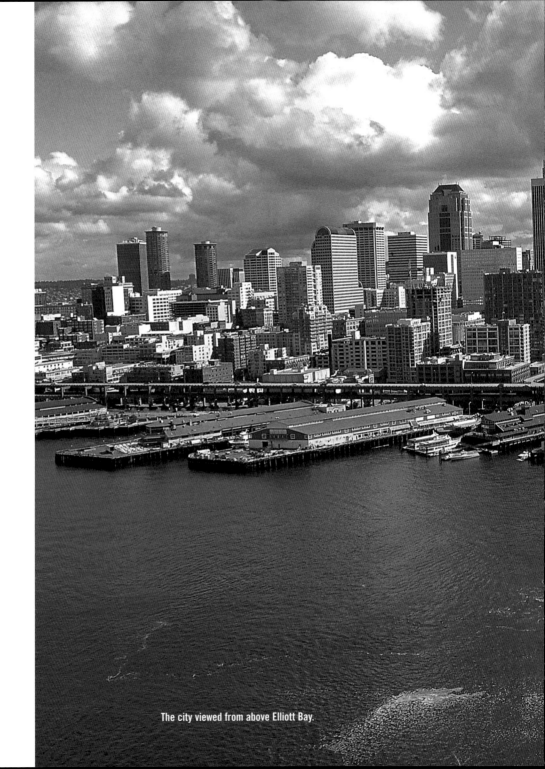

The city viewed from above Elliott Bay.

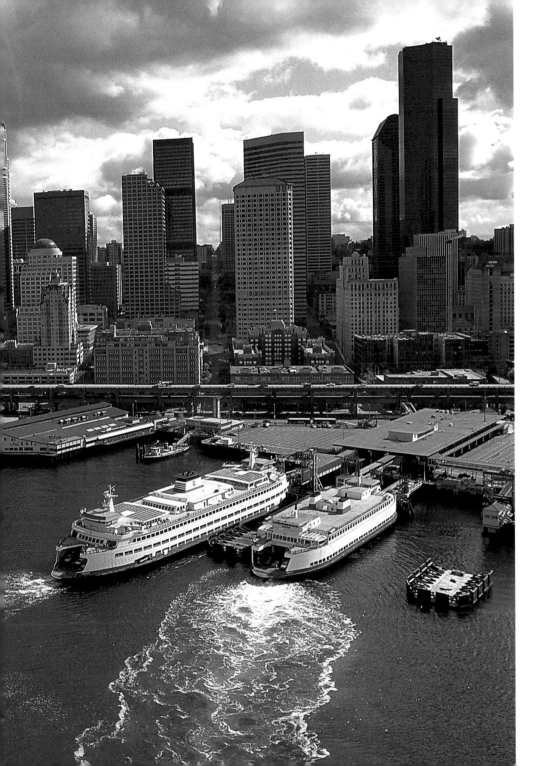

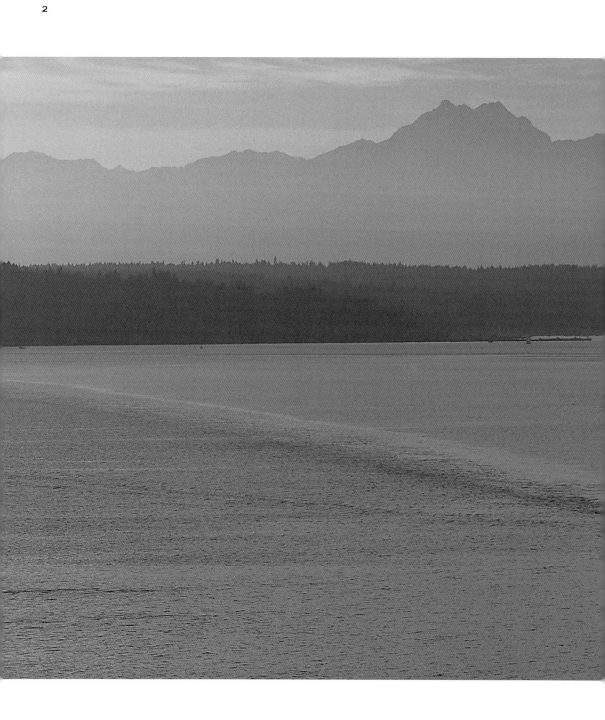

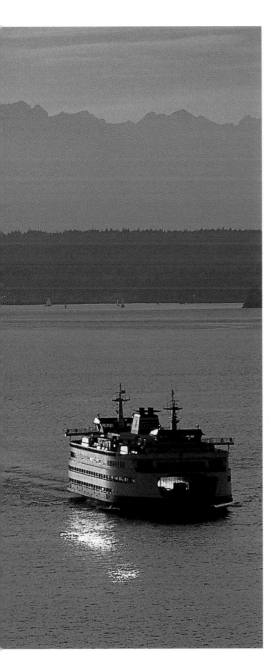

Left: Washington State Ferry crossing Elliott Bay.

Below: Roof garden above Pike Place Market.

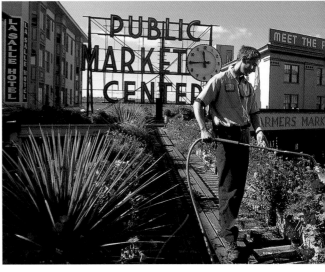

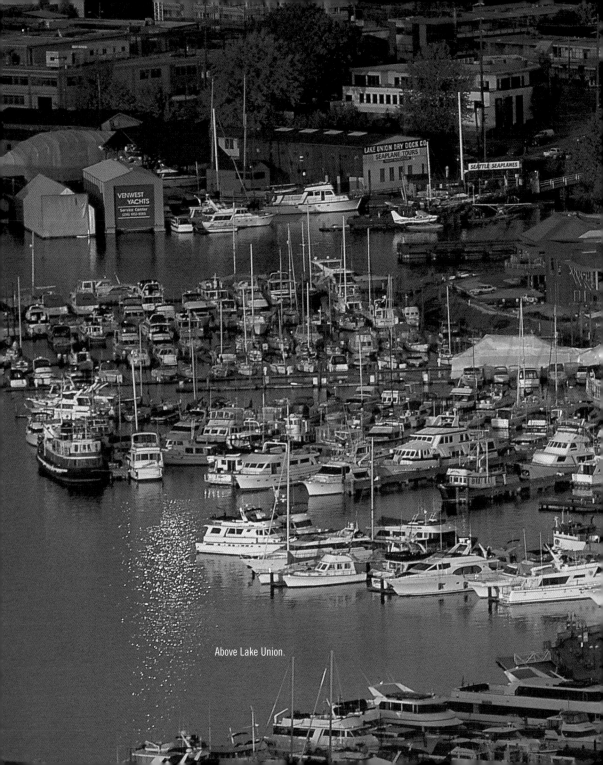

Above Lake Union.

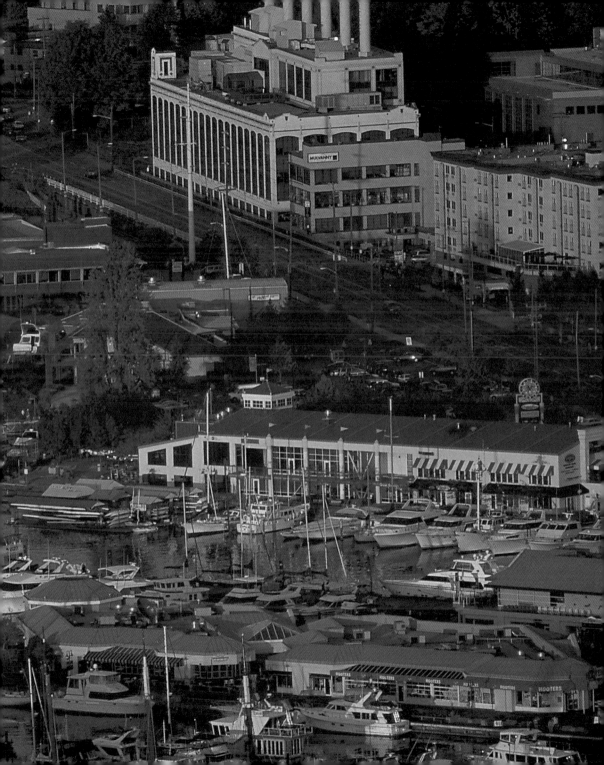

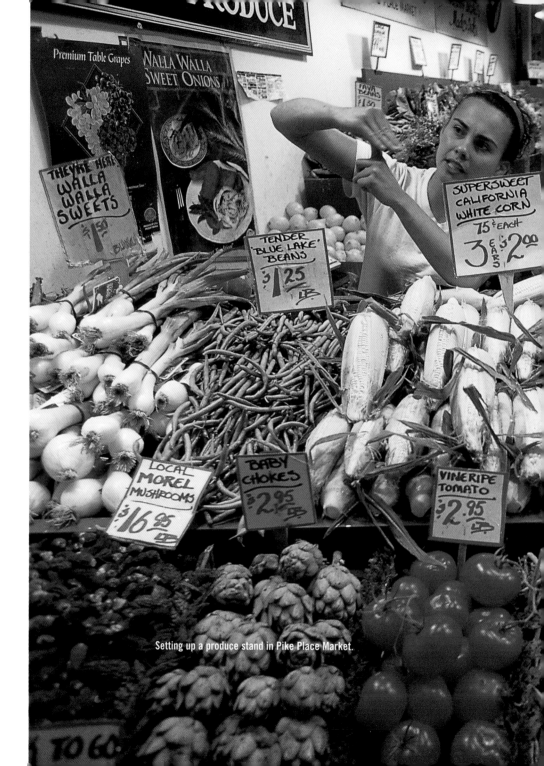

Setting up a produce stand in Pike Place Market.

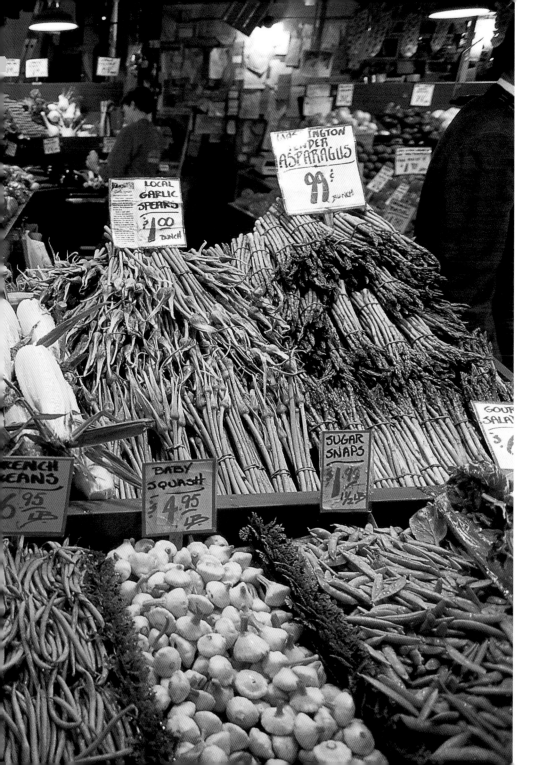

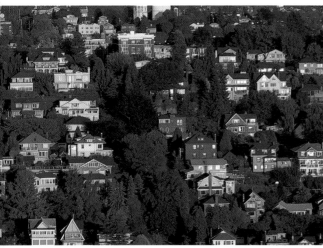

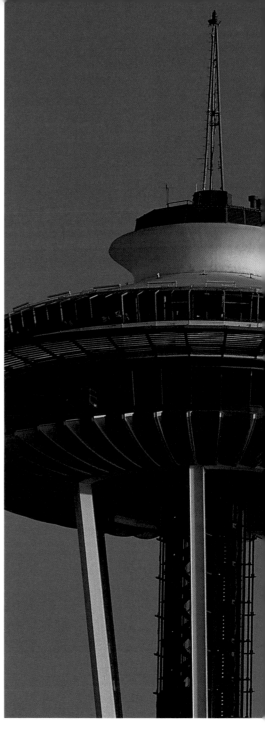

Top: In-line skating around Green Lake.

Above: Looking east toward Queen Anne Hill.

Right: The Space Needle and passing jet.

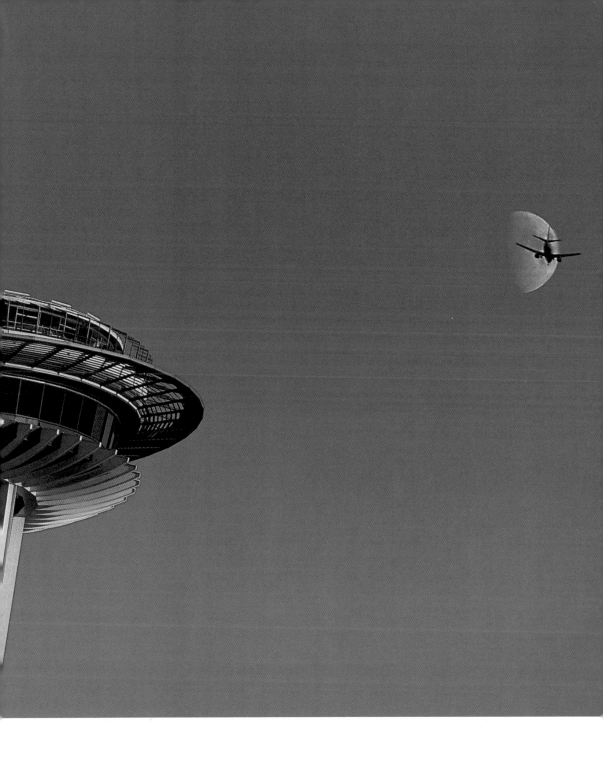

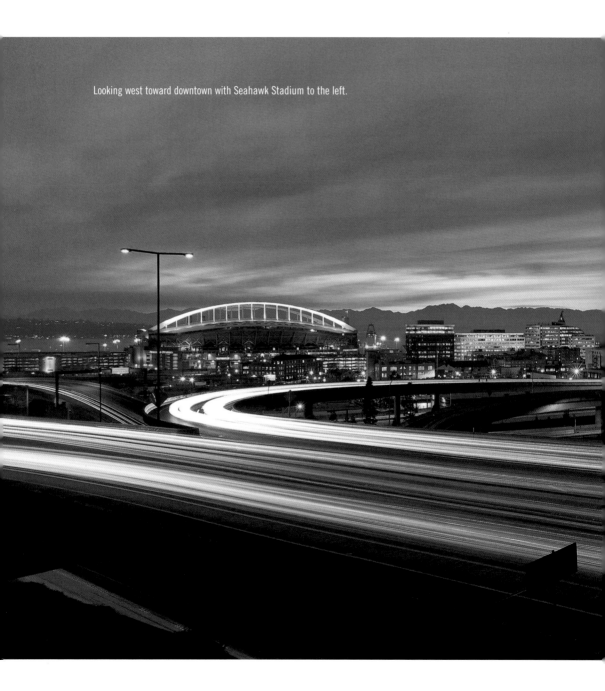

Looking west toward downtown with Seahawk Stadium to the left.

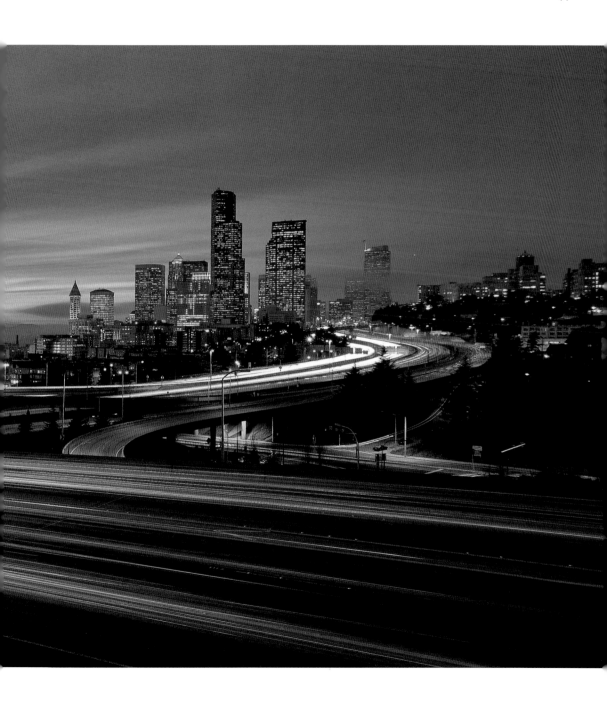

I GREW UP IN THIS PLACE. BUT I DIDN'T BEGIN TO UNDERSTAND IT UNTIL THAT MORNING.

It was 6:30 AM on a drizzly Monday in December, 1991. After several years away in Florida, I'd just returned to Seattle to host "Morning Edition" on KUOW-FM, our local NPR station. As usual, it had been raining for the last forty days and forty nights, but I told my listeners that the weather was supposed to "improve" later that week. Immediately all the phone lines started blinking. Why were people calling? God, what did I say? Did I end a sentence with a preposition? Did I mispronounce Sequim? Turned out, it was an even bigger sin. Angry listeners were calling me to defend the rain. "Don't tell me which weather I like." "Don't put your 'value judgment' on my weather." "We like the rain, thank you very much."

I couldn't understand it. I mean, no land mammal likes to be damp, right? Have you ever seen a cat lounging on a wet sidewalk? Sure, a dog will chase a ball into a lake, but that's because dogs are stupid. So what was wrong with these people? Well, since then, I've come to appreciate this as an attribute unique to Seattle, a quality that has sustained us from the city's very beginnings in 1851: the ability to hallucinate. Or, at least, to see the world as we wish it were.

As Seattle founders Denny, Boren, Bell, and their wives paddled up to what is now West Seattle on November 13, 1851, what they found was not promising. The shore was rainy, windy, and cold, and had that funny beach smell. Ordinary people would have turned right around. But these pioneers were no ordinary people. No, somehow they were able to squint through the spray at that gray, miserable, scraggly marsh and blatantly lie to themselves. Borrowing the local Indian word for "by and by," they called their new home "New York Alki."

In true Seattle fashion, these settlers saw this spot not for what it was but for what they wished it were. They soon moved their settlement from Alki to the shores of deeper Elliott Bay. They cleared forests and flattened hills. They convinced Henry Yesler to build his sawmill here. Doc Maynard traveled down the coast recruiting the blacksmiths, bankers, and outfitters the town needed. And, when all the men looked around and realized they were all men, they went and fetched some women. Seriously. A carpenter named Asa Mercer sailed around to Massachusetts and convinced some maidens to come back with him to start a Seattle baby boom. They made a TV series about it in the late '60s called "Here Come the Brides," starring several mildly pretty actresses and the beautiful Bobby Sherman. The show may have been mediocre, but the theme song, "The Bluest Skies You've Ever Seen Are in Seattle," still stands as a stunning piece of blind optimism. Very Seattle.

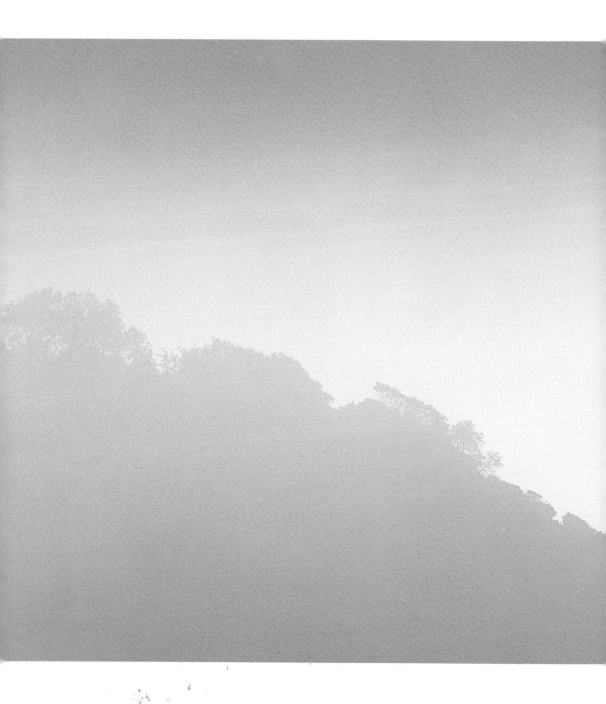

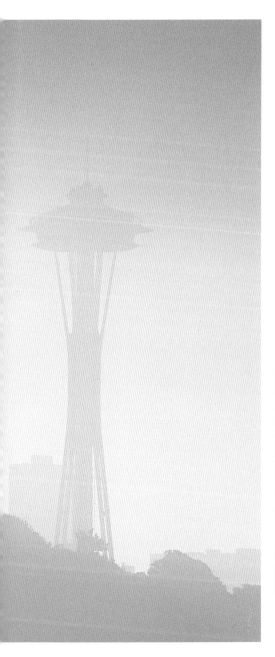

Left: The Space Needle in morning fog.

Above: Hardcore Seattleites shun umbrellas in favor of GORE-TEX®.

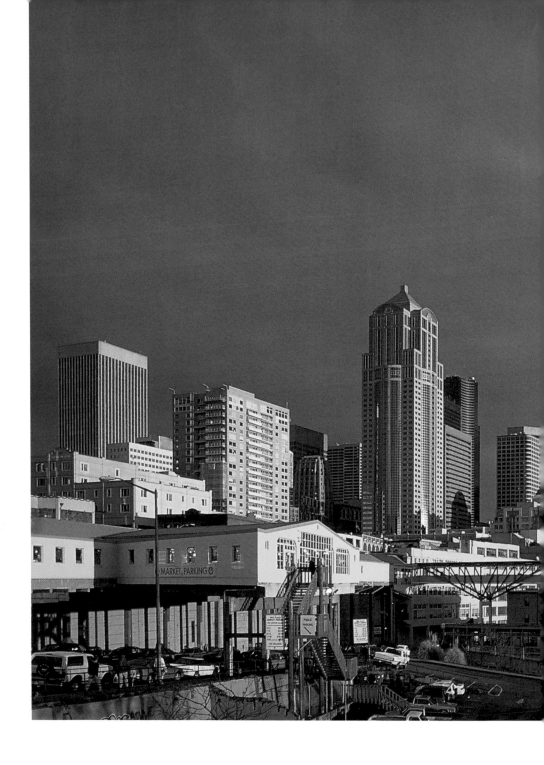

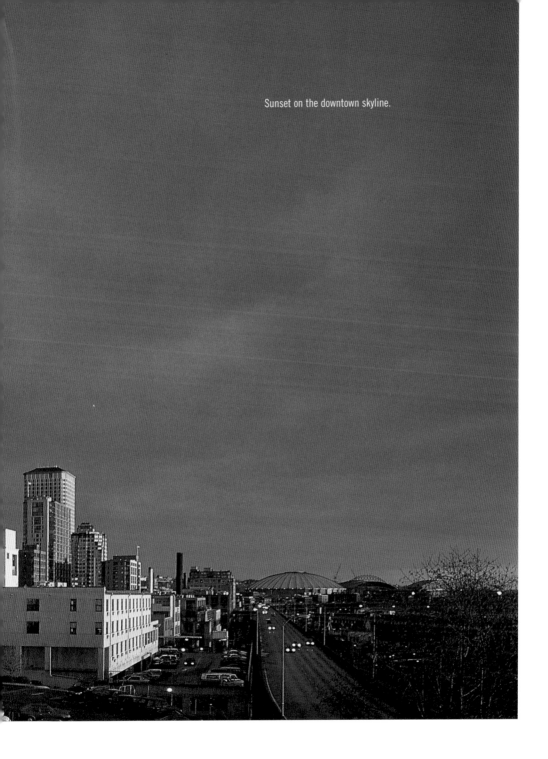

Sunset on the downtown skyline.

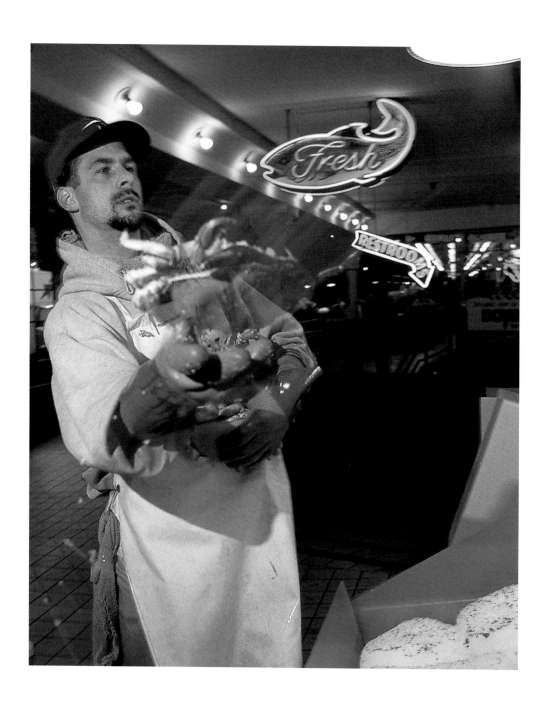

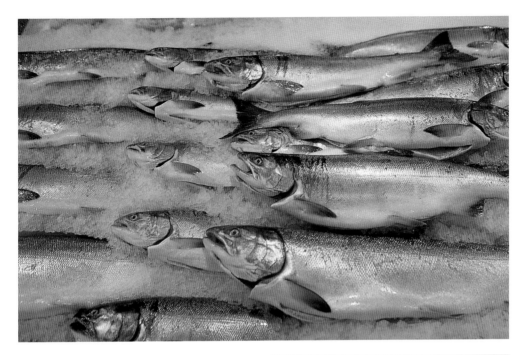

Left: Catching a flying crab at Pike Place Market.

Above: Alaskan salmon for sale.

Romance at Pike Place Market.

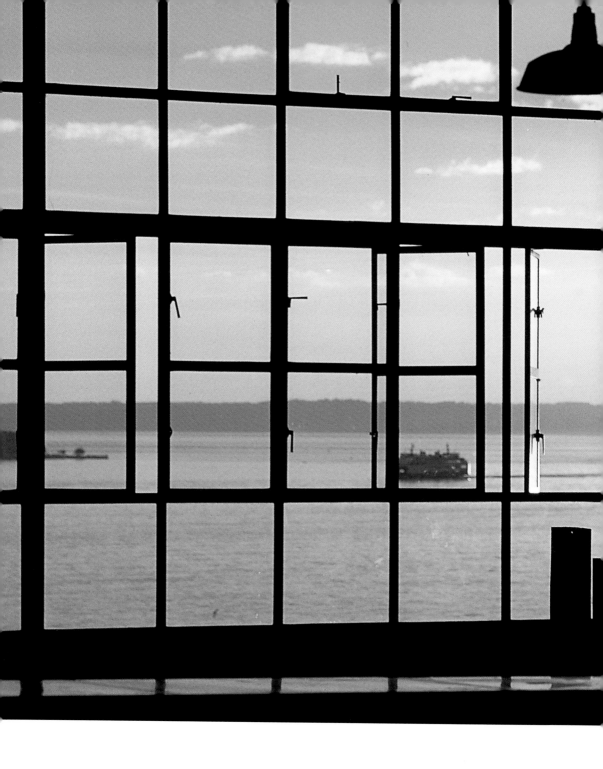

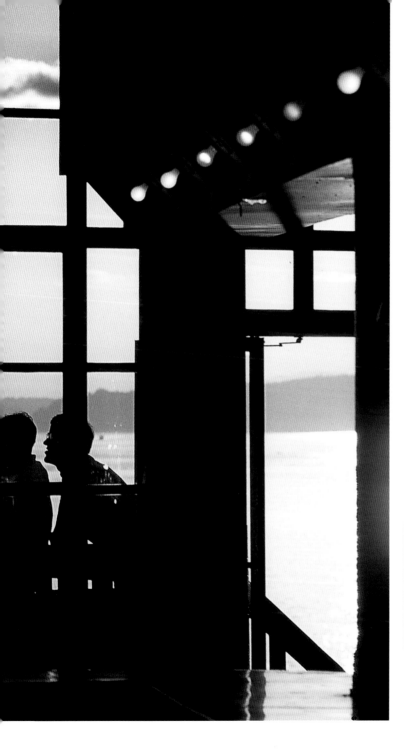

Left: Overlooking Elliott Bay from inside Pike Place Market.

Below: Seattle's Best Coffee calling.

TO THOSE WHO SAY SEATTLE HAS LOST ITS SOUL, I HAVE THREE WORDS: "GIANT SHOE MUSEUM."

Also Jack's Fish Spot, The Creamer, The Pink Door, Lid Wea, Emmett Watson's Oyster Bar, Clayzeness Whistleworks, Tusong Thao Gardens, and the Women's Hall of Fame. Pike Place is a blooming, bustling, chain-store-free heaven. The only corporate exemption is for Starbucks, and that's because this is the location of their first store. The Starbucks on Pike Place opened in 1971, and they still display the company's original mermaid logo from before she ate the corporate apple and became aware of her nakedness.

The Market is almost too wonderful. When it's quiet enough in the arcade to hear yourself creaking down the thick, wooden steps, you might creep along the hallways, through the smell of incense and used books, and wonder if the world is a good enough place for all this to last. After all, why would shoppers keep coming downstairs to the Silly Old Bear toy store when they can one-click Winnie-the-Pooh into their e-shopping basket at Disney.com? How many Juggling Fire Torches and Billy Bob Teeth can the Magic Shop sell? I mean, if the Boeing Military Aircraft Missile Systems Commercial Airplane Business Jet Space & Communications Capital Corporation couldn't survive in Seattle, how are the Hmong pillowcase-makers doing? And how solvent is a bead store whose sign has had the words "That's Bead, not Bread that you eat" hand-scrawled on it for decades? Well, not solvent enough, apparently. That shop, Craft Emporium, is now gone, replaced by The Bead Zone, and that famous old sign is gone. Yet despite being a retail David in a world of Goliaths, Pike Place Market thrives. To those who some-

times worry that Seattle has lost its soul, the Market is a many-splendored balm. This isn't remote little Lopez Island, for God's sake, this is one of the prime retail locations in the world. And it's home to Big Dipper Wax Works and The Daily Dozen Doughnut Company. How about you, are you doing your part? You'll eat a free cracker with pepper jelly on it, but do you ever buy the pepper jelly? You've looked at the pencils shaped like twigs and you still don't own one. Why should the fishmonger go on jerking the monkfish with a string if you're just going to jump nine feet into the air, wet yourself, take a picture of the monkfish, and leave it sitting on the ice with its mouth propped open with a stick?

Actually, the fish throwers will always be OK, because they have a gimmick. Not only do they have a great visual in "flying geoduck," but they do a killer audio show, too. I once brought my tape recorder down to do a radio story about them. Between the cigarettes and the vocal-cord polyps, there is no recording level that is appropriate for both those fishmongers and normal human beings. I was gathering the ambient sounds of shoppers milling around, when one of the mongers turned in my direction and screamed, "EIGHT POUNDS OF SOCKEYE, SHIP IT TO CANADA!" Now I'll never hear the music at my child's wedding.

When you visit Pike Place Market, come on foot. Occasionally, even a local who's driving downtown will lose his head and absent-mindedly turn west off First Avenue, onto Pike. In a horrible instant, he realizes his blunder and knows that he may never see his loved ones again. Pedestrians file in front of him endlessly, one at a time, like camels. Tourists in rental cars sit idling, optimistically waiting to be let through, as if their gas tanks could hold that much fuel. Our friend knows he'll be there until nightfall, and there's nothing to do but abandon his vehicle and go look for the historic brick he paid for. I still haven't found mine.

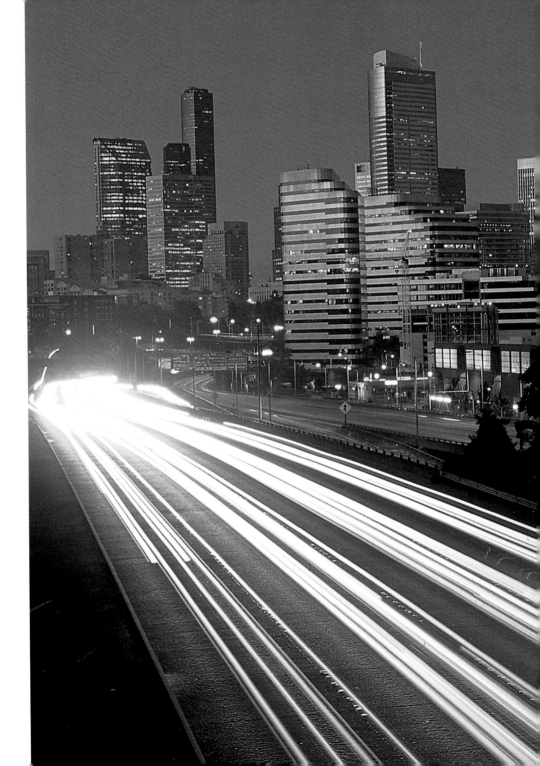

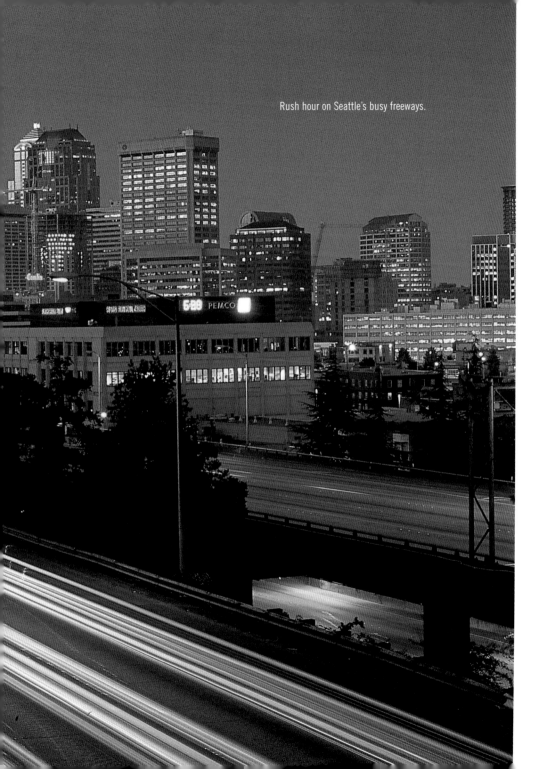

Rush hour on Seattle's busy freeways.

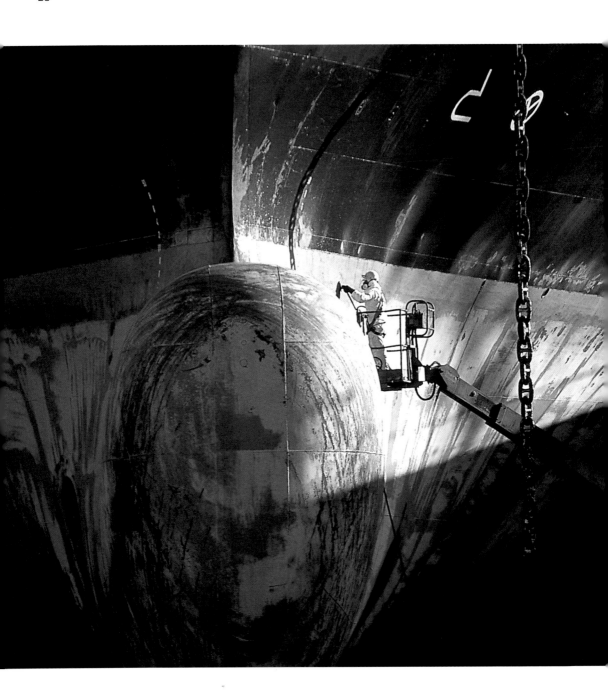

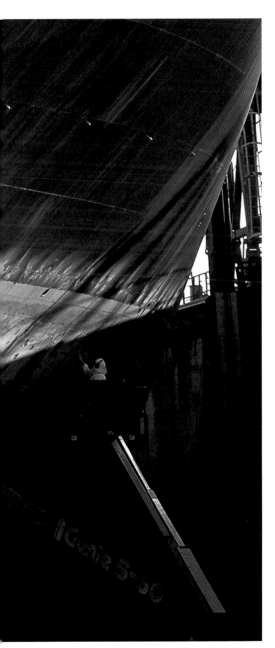

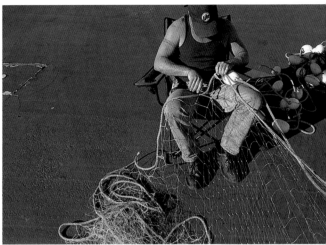

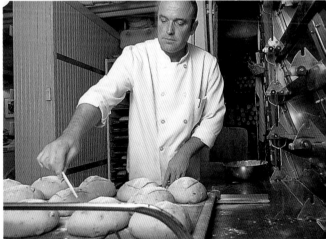

Left: Sandblasting a cargo ship in dry dock along Elliott Bay.

Top: A commercial fisherman separates cork from a salmon gillnet.

Above: Morning loaves at Le Panier Very French Bakery.

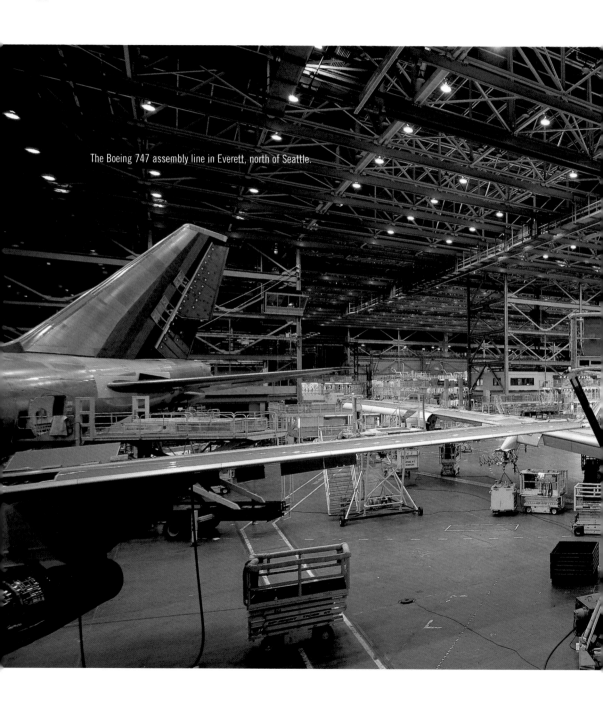

The Boeing 747 assembly line in Everett, north of Seattle.

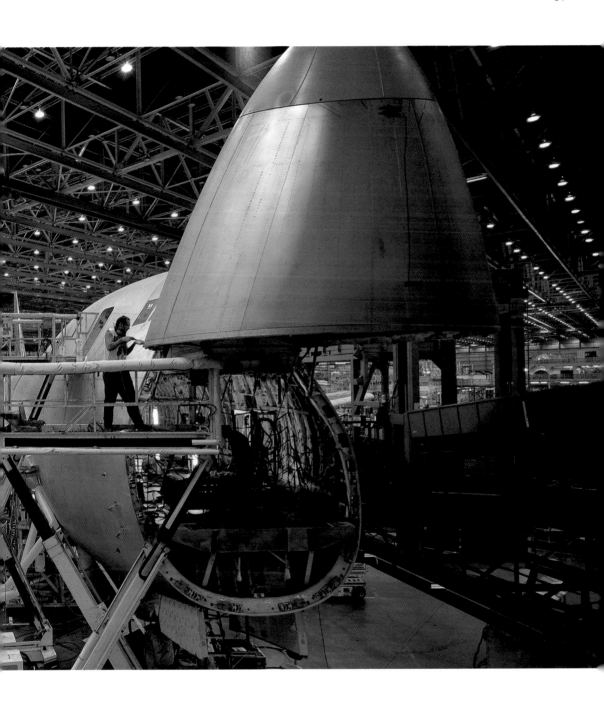

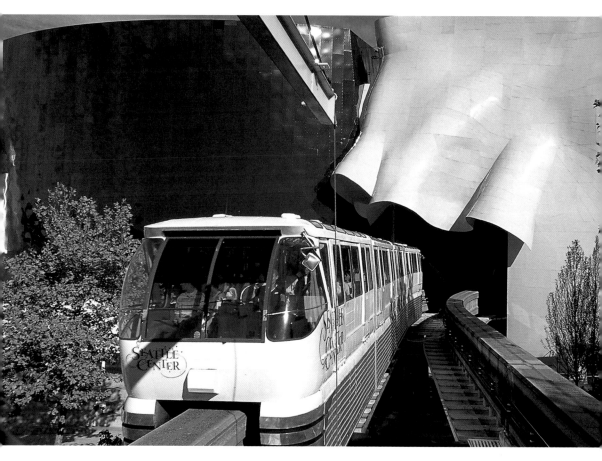

Left: The Experience Music Project was built around the existing monorail track.

Right: Monorail operator Megan Nielson at work above the streets of downtown.

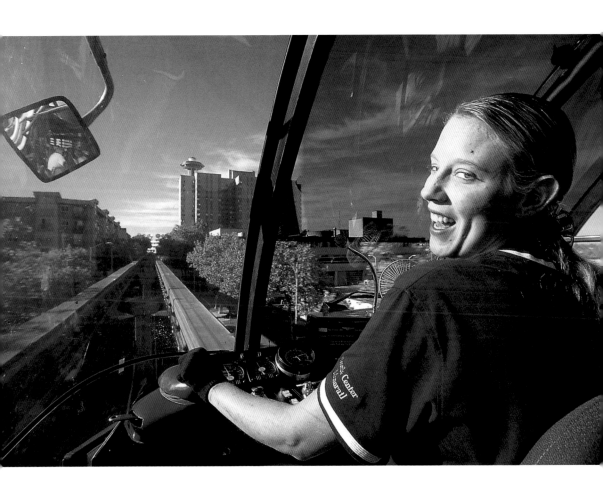

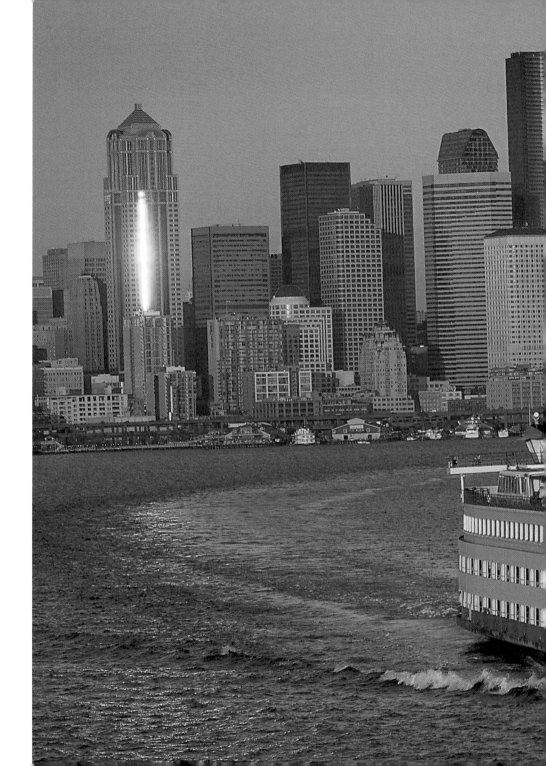

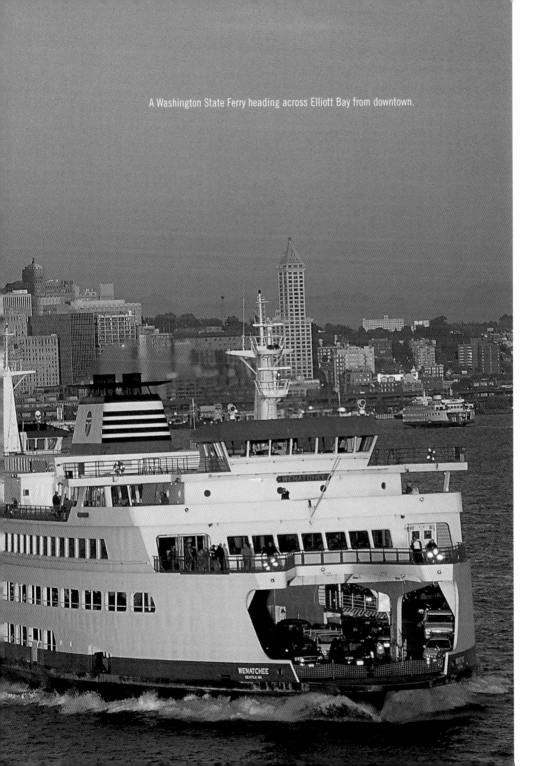

A Washington State Ferry heading across Elliott Bay from downtown.

MOST CITIES HAVE AS THEIR SYMBOL A MONUMENT, A SKYSCRAPER, MAYBE A BRIDGE. WE HAVE A FLYING SAUCER ON A POLE.

And we love it. The Space Needle was built for the 1962 World's Fair as a celebration of our future. (The fair's theme was "Century 21.") It's no surprise that in Seattle's imagination, the future looks like a giant umbrella.

The Needle is located next to the Experience Music Project, a tribute to native son Jimi Hendrix, whom we completely ignored while he lived here. (Thirty years later, determined not to repeat the mistake, we would give Grunge Rockers far more attention than they wanted.) The Frank Gehry-designed EMP is an architectural Rorschach. Some look at it and see undulating musical improvisation; others would swear Walt Disney threw up. "Pile of medical waste" or "wreckage of the Partridge Family bus"? Each viewer must decide for him or herself.

When the mountains are "out," the view from the Space Needle is actually a little ridiculous. If this were your first landscape painting, your teacher would say you're trying to do too much; you need to make some hard choices: Is this painting about majestic skyscrapers or cruising ferries? Rolling hills or sparkling lakes? And if you must use the old "snow-capped peaks" cliché, for God's sake, pick one side of the frame, not both. Yes, it's easy to see why every year thousands of tourists visit the Needle's revolving restaurant, gaze across the changing vistas, and ponder life's intractable mysteries. Like, how can a restaurant that's always moving have a smoking section?

From the Space Needle, the first thing you notice is all the blue—if you're looking down, that is. Whether it's dripping, flowing, lapping, or cascading, water is in Seattle's veins. The working waterfront's orange

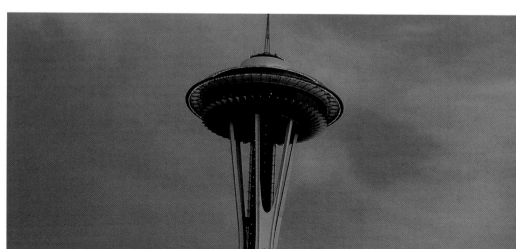

cranes look like high chairs for the Toddlers of the Gods. At the Ballard locks, salmon fly through the air to tourists' delight; those that aren't fast enough end up at Pike Place Market, flying through the air to tourists' delight. On Christmas Eve, kayakers row among the houseboats singing about heavenly peace at the top of their lungs. Even our bridges float. Why, you can paddle right up to Bill Gates's property line! (Don't mind the underwater lasers and armed frogmen.)

For a longtime Seattle resident, the most striking sight from the Space Needle is the Twin Stadia, the Hydra that sprouted when we cut off the head of the Kingdome. Now, the Kingdome was in no way attractive. NPR host Bob Edwards once told me—on the air—that "when you go to the Kingdome, you get the feeling the Germans won the war." But then, we used to like our civic structures that way. Seattle's Municipal Building is pitifully bleak. Across the street, the King County Administration Building is a dingy egg carton. Our old two-minute monorail may be a hunk of concrete, and may not have the same glamour as transit systems that "go somewhere." But it does its job. Whatever that is.

Designers of the new monorail line promise that it will be pretty, with rounded columns, arched guideways, bright lights, and steel beams. The plainness of Old Seattle used to be part of its charm. We were a dull and frugal people; we had mountains and water, and that was all the beauty we needed. That's changed. Since the money rolled in, in the 1990s, Seattle has acquired a taste for the finer things, including sports chateaux like Safeco Field and Seahawk Stadium. Of course, a few Mariners' playoff runs helped a lot, too. No Seattleite will ever forget the watershed pennant race of 1995, especially the sight of the Yankee fans throwing garbage onto the field and the Seattle players running around separating it.

The symbol of the city is evident everywhere.

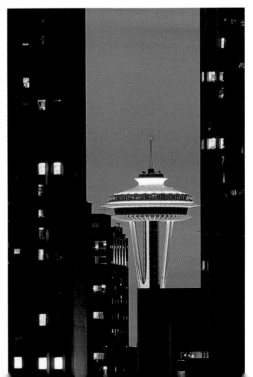

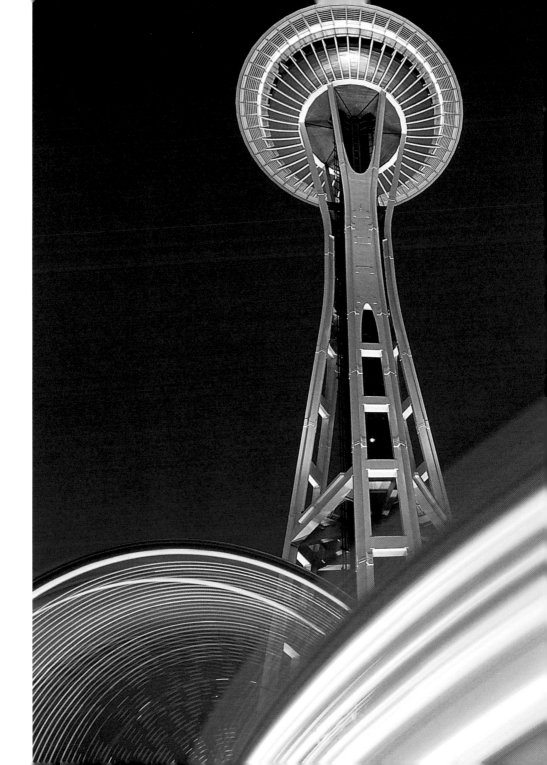

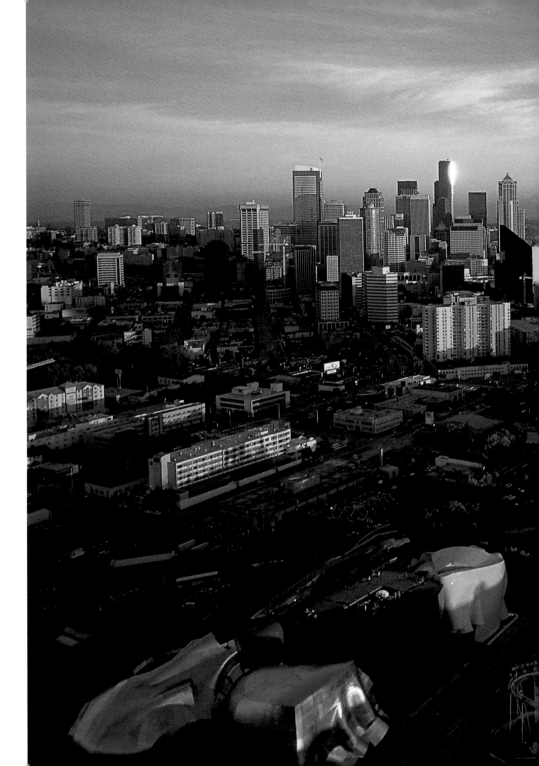

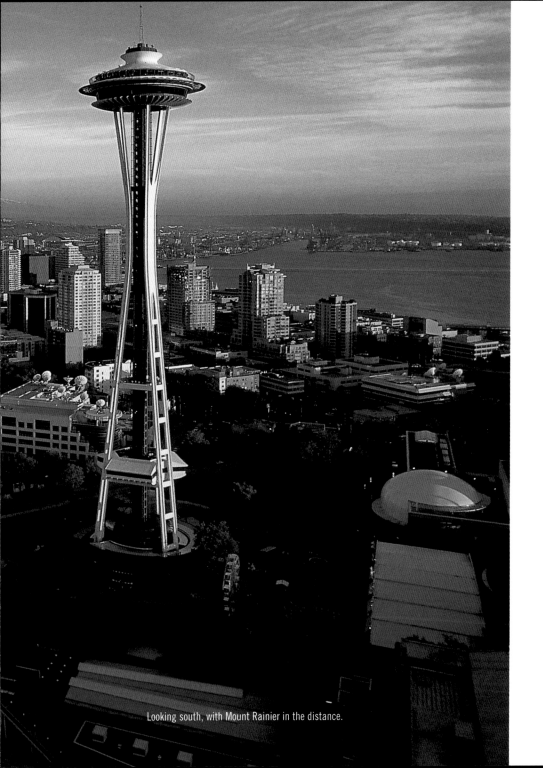

Looking south, with Mount Rainier in the distance.

IF NO ONE CAN SEE A BEAUTIFUL MOUNTAIN, IS IT STILL BEAUTIFUL?

Maybe not, if you're a tourist who's come thousands of miles to see what was on the cover of your travel brochure. But to us, Mount Rainier is a tantalizing treasure. At 14,411 feet, it is the world's tallest pun—if it were any Rainier here, we'd never see it at all. Even on a sunny day, "The Mountain" is often topped by a cloud yarmulke where wet air meets cold summit. And although you'll never see it on a T-shirt, the shy, shrouded Rainier is the one we know and love best. Like Jimmy Stewart's Elwood P. Dowd, we know it's there, even if no one can see it. We just go on hiking, camping, and boating all year long, acting as if our

big, white, invisible friend were in plain view, while the rest of America scratches its head and says, "Don't they know it's raining?"

When Mount Rainier does make a rare appearance, it can make us a little giddy. Traffic slows, office workers pause, people with views remember why they spent the money. One time, after climbing nearby Pinnacle Peak, I pulled over at a viewpoint to admire the lovely blue-and-white Nisqually Glacier. Patiently, I waited for the man ahead of me to snap his photo so I could take over his vantage point and get my own shot. Two, five, ten minutes later, the guy hadn't moved, so I walked up next

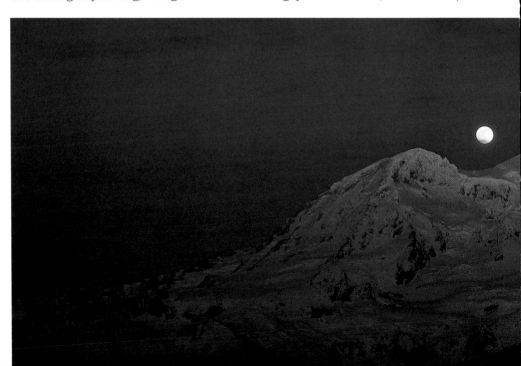

to him and saw what the holdup was. He was videotaping the glacier. Now, I don't know what kind of VCR he had, but that is one hell of a fast-forward feature.

The U.S. Geological Survey lists Rainier as the most dangerous volcano in the country, so you'd think we'd be scared. But recent experience keeps encouraging us to be blasé. Sure, Mount St. Helens blew in 1980, but most of the talk was about how much worse it could have been. "Plenty of warning, lucky it happened on a Sunday, lucky the wind wasn't blowing toward a big city," and so on. We're so cocky that our way of paying tribute to St. Helens' unpredictable ferocity was to establish a gift shop next to the crater. Likewise with the giant overdue earthquake that we've been warned about for decades. On February 28, 2001, a Big One finally came and it wasn't That Bad. The only people truly frightened were the hardcore coffee drinkers, to whom the Earth appeared to stand still for several seconds. I hope I'm not jinxing us.

Every year 10,000 people try to climb Rainier, and every year 12,000 guys tell women they've made it—an astonishing success rate. Still others have yet to scale Rainier, but they have something even more valuable: They plan to, which is much more satisfying. After all, climbing the mountain only takes a weekend, and you're left with nothing but a few snapshots and a nagging sense of accomplishment. Planning the climb—if done correctly—can last a lifetime.

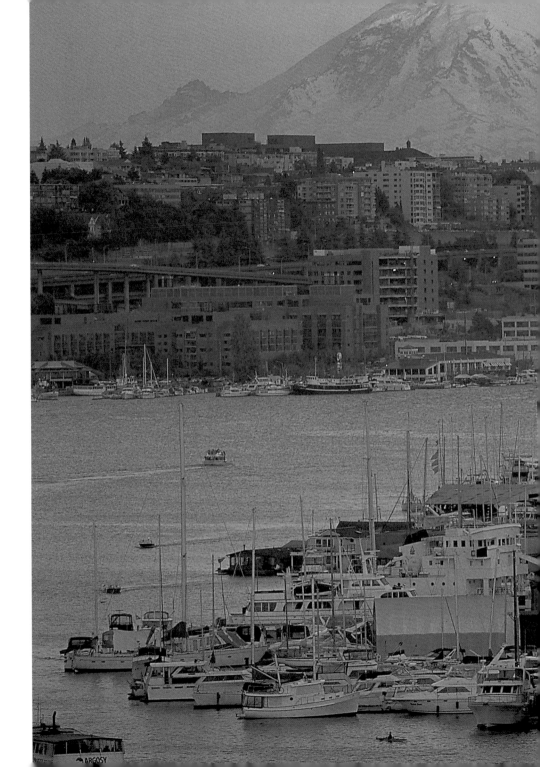

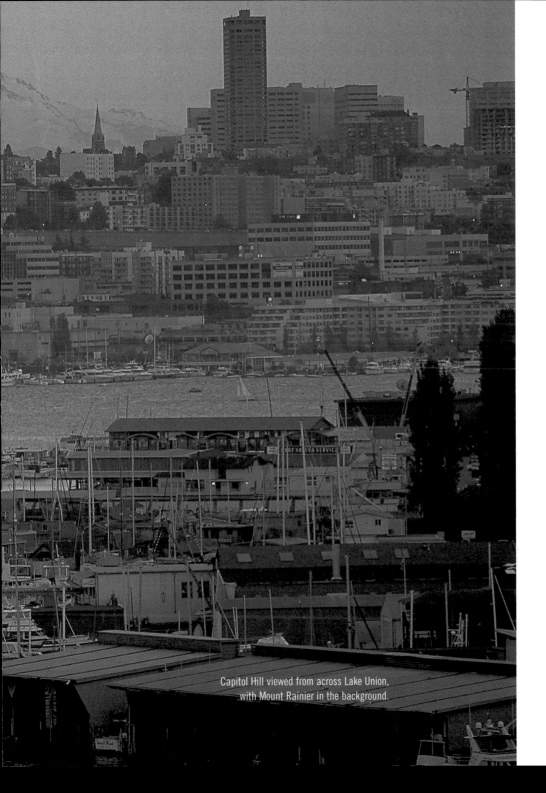

Capitol Hill viewed from across Lake Union,
with Mount Rainier in the background.

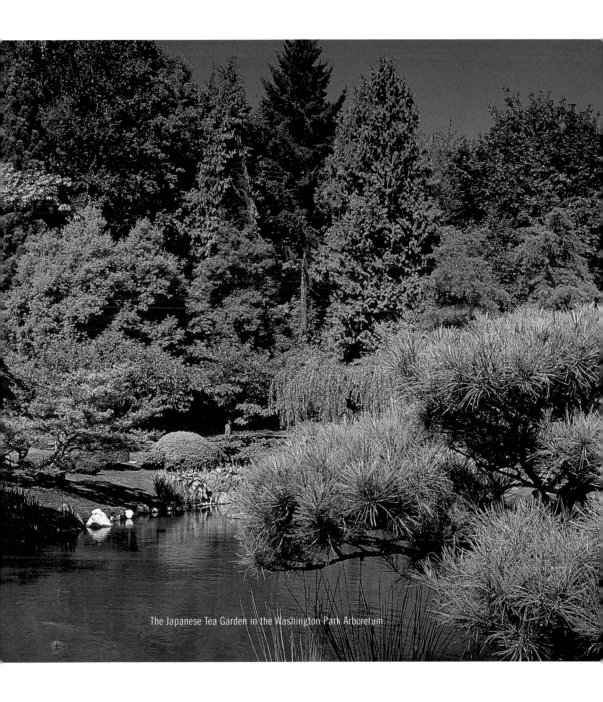

The Japanese Tea Garden in the Washington Park Arboretum.

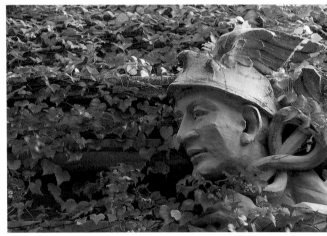

Left: Residential street in the Capitol Hill neighborhood.

Top: A home in the Alki neighborhood.

Above: Gargoyle covered with ivy at the University of Washington.

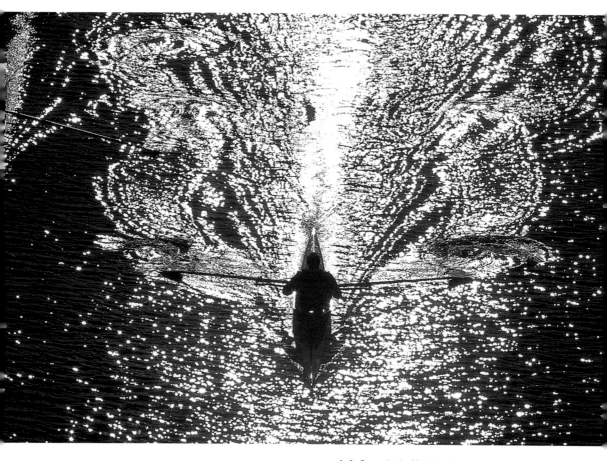

Left: Rower in the Montlake Cut.

Right: Rowing sculls on Lake Union.

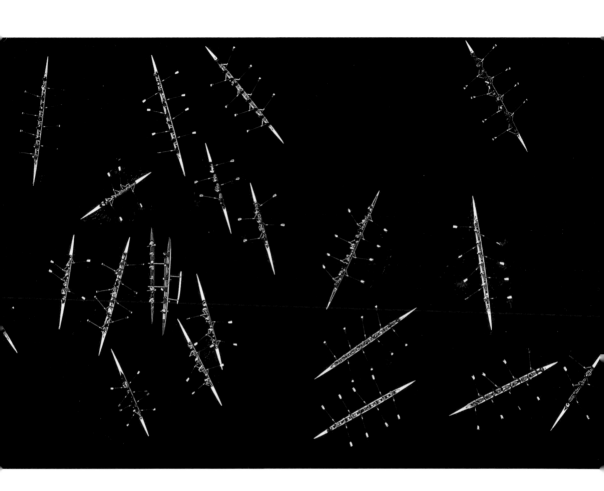

ANYWHERE ELSE IN THE COUNTRY, EVEN A CHILD KNOWS THAT A RAINY DAY IS AN INDOOR PLAY DAY.

But the way Seattle plays is a triumph of optimism. Whether it's sparkling white in the mountains, or sparkling blue below, we know how to turn water into fun. You can scream out of a careening hydroplane, or kayak serenely right up to your 7:30 dinner reservations. Snow lovers can churn cross-country through the Methow Valley, snow-shoe through powder at Paradise, or fight the wet cement at Snoqualmie. Animal lovers can ogle orcas off the San Juans, or bird-watch from a canoe on the Nisqually Delta. Thrill-seekers can surf with the wind down the Columbia Gorge, sailboard faster than the Green Lake geese can flee, or hold the water-ski rope with one hand and wave to Bill Gates with the other.

And I haven't even gotten to the pleasure boats. When you're on the road fighting traffic and the clock, it's heartbreaking to reach one of Seattle's four bascule bridges and see the red lights flash and the Arm of Lateness descend in front of you. But admit it: In a nation that's chained to the automobile, isn't it kind of beautiful that a line of cars has to idle while the road rises

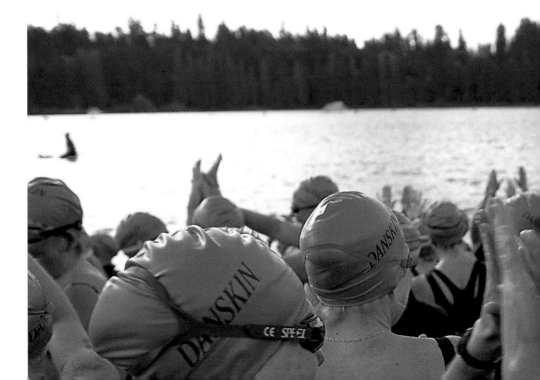

to let a boat drift by? It's especially galling for the landlubber driver because all that damn water is a big reason our traffic is so awful in the first place. You see, Seattle is squeezed skinny at the waist by the girdle of Puget Sound on one side and Lake Washington on the other. Because of our slim figure, there's only room for a few north-south roads and they're constantly clogged. How sweet then to putt-putt through the Ballard locks or sail on a gentle northerly wind under the car-choked 520 high-rise.

Fortunately, we don't need water to have fun. A dry spell just means the rocks you climb will be less slick, the trails you hike less muddy, the bike paths less puddly—oh, yes, the moistest city in America is somehow a bicycling mecca. The Burke-Gilman trail alone has a million users a year. As *Bicycling Magazine* says, "You, too, would drink a lot of coffee if your daily riding options were this good."

That's the key to having fun in our climate: Plan for rain, appreciate sun, be happy either way. In January, sunshine is a gift; rain means "race you to the lift."

If it's raining, play. If it's not, play. Even when we're working we dress like we're playing. Many a Seattle office worker keeps a white shirt, tie, jacket, and dress shoes in the company closet and takes the outfit home once a year to clean off the dust.

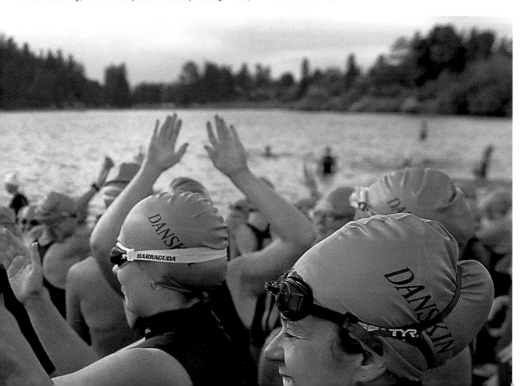

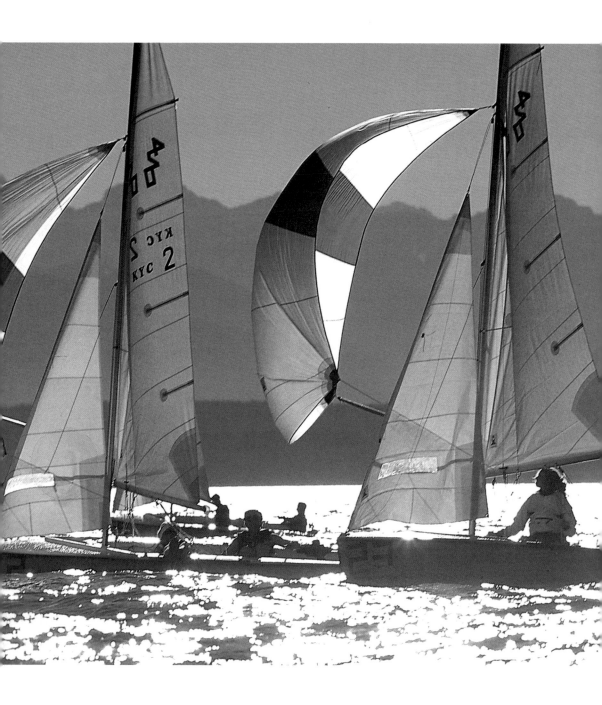

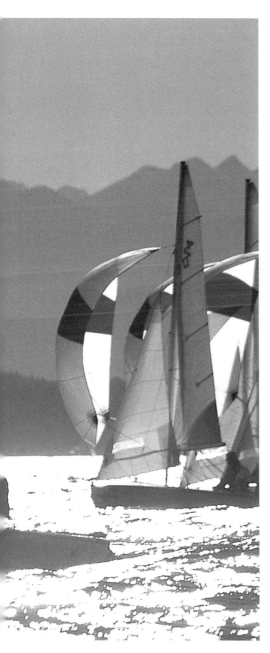

Left: Sailing on Elliott Bay.

Below: Volleyball on a Puget Sound beach.

Bottom: Mountain biker heading toward the mud.

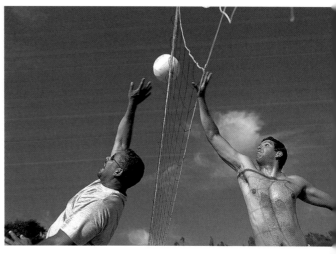

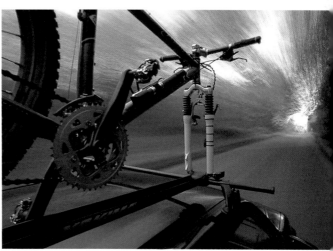

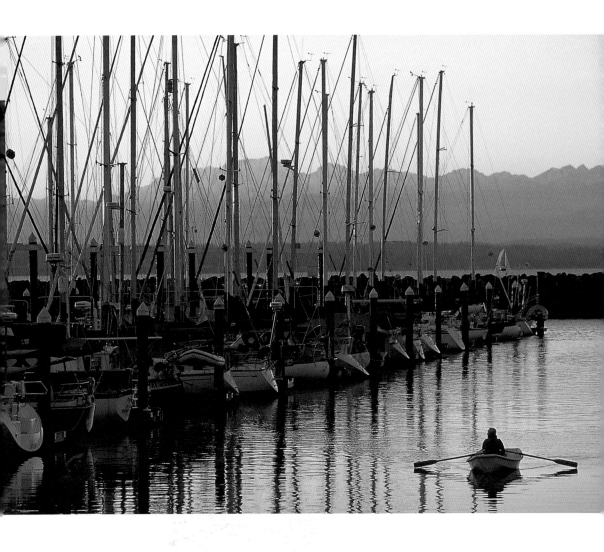

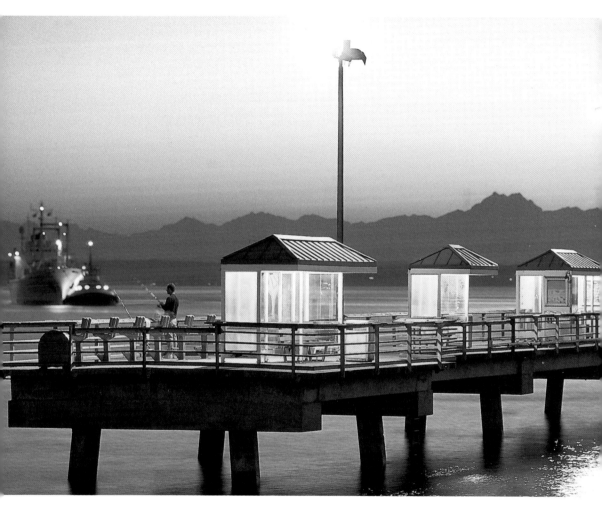

Left: Shilshole Bay Marina on Puget Sound.

Above: Fishing pier on Puget Sound with the Olympic Mountains in the distance.

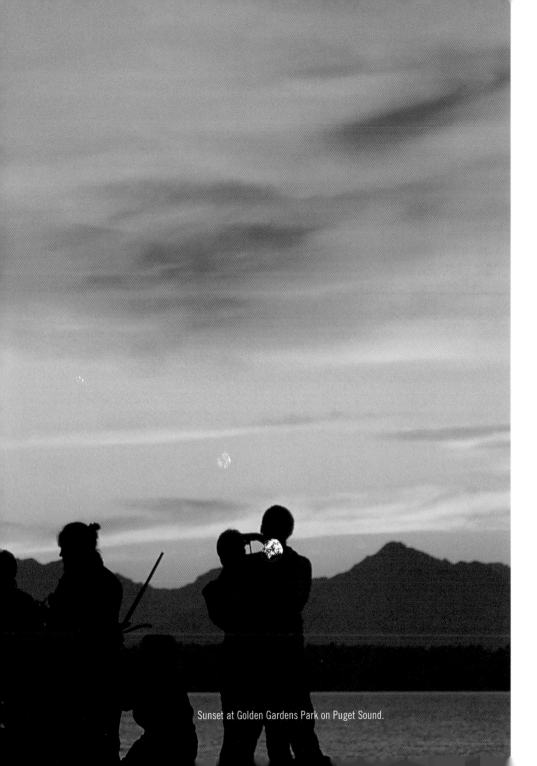

Sunset at Golden Gardens Park on Puget Sound.

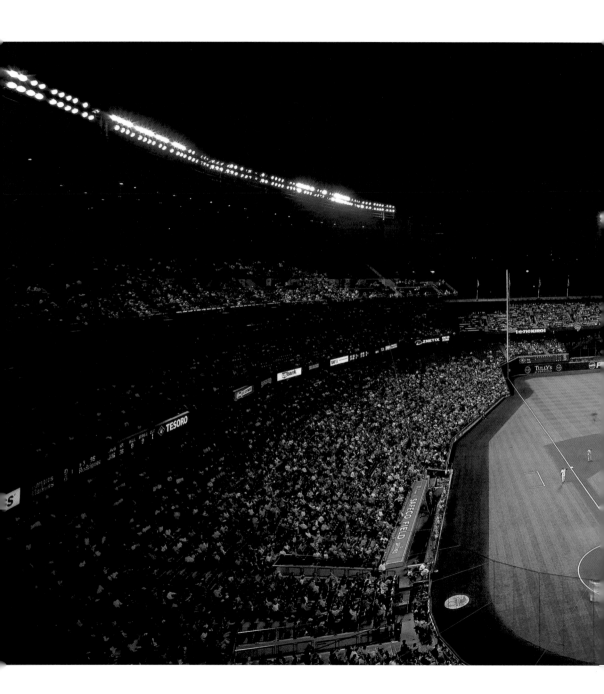

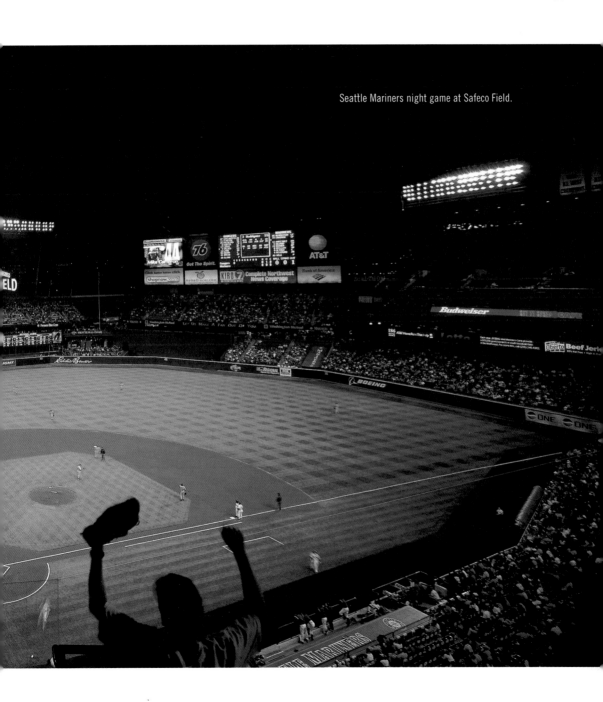

Seattle Mariners night game at Safeco Field.

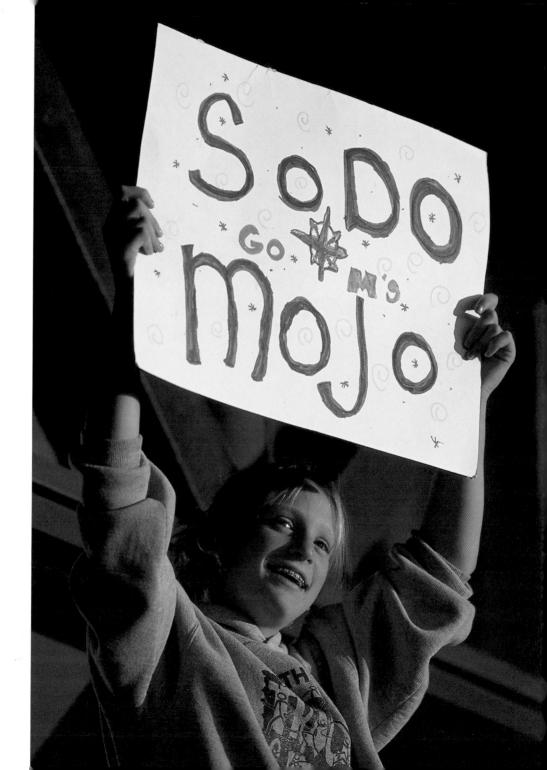

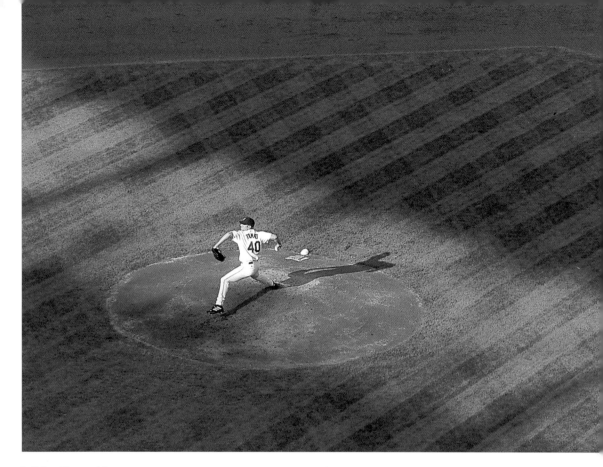

Left: Local team spirit.

Above: On the mound at Safeco Field.

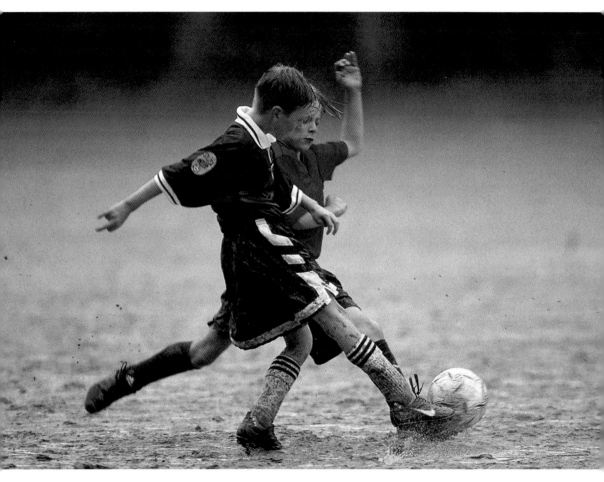

Above: Youth soccer in Seattle is seldom played on grass.

Right: Weekend hoops at Green Lake.

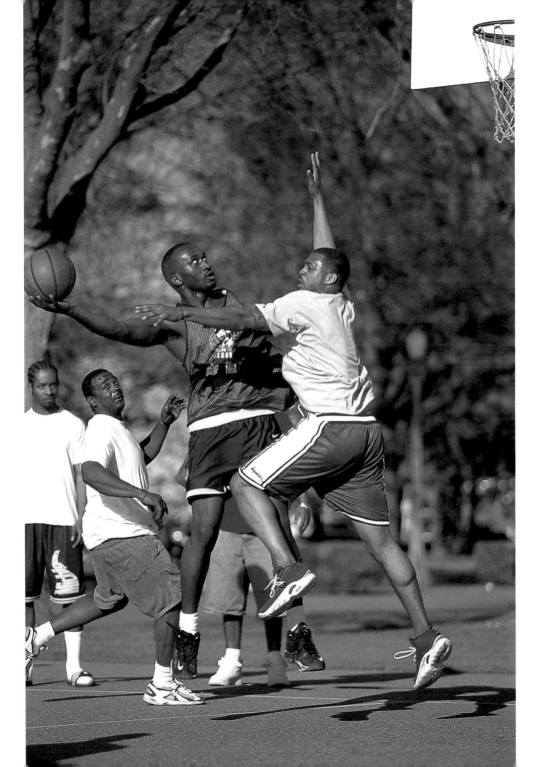

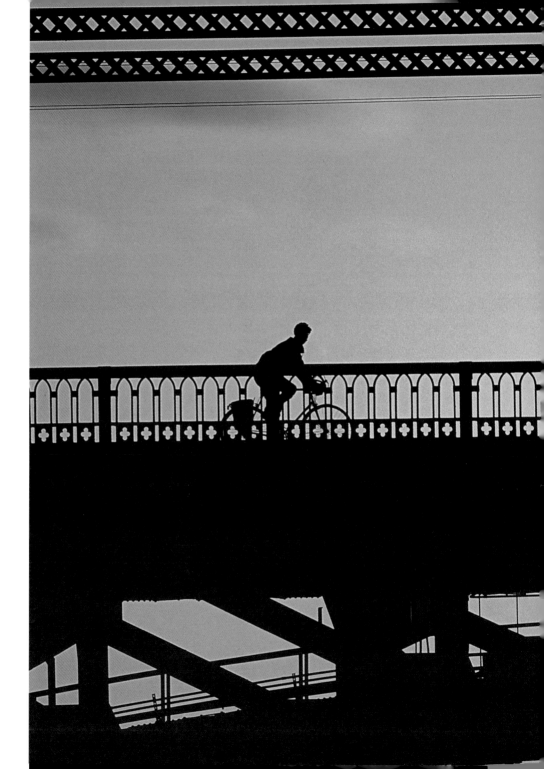

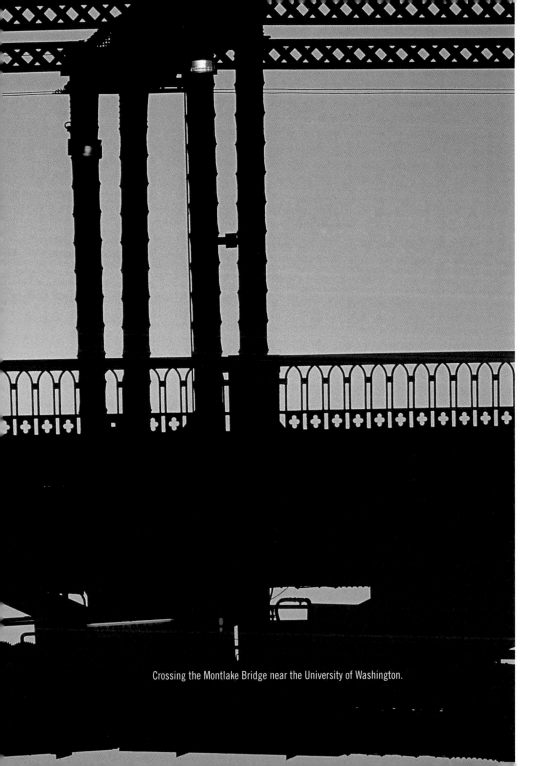

Crossing the Montlake Bridge near the University of Washington.

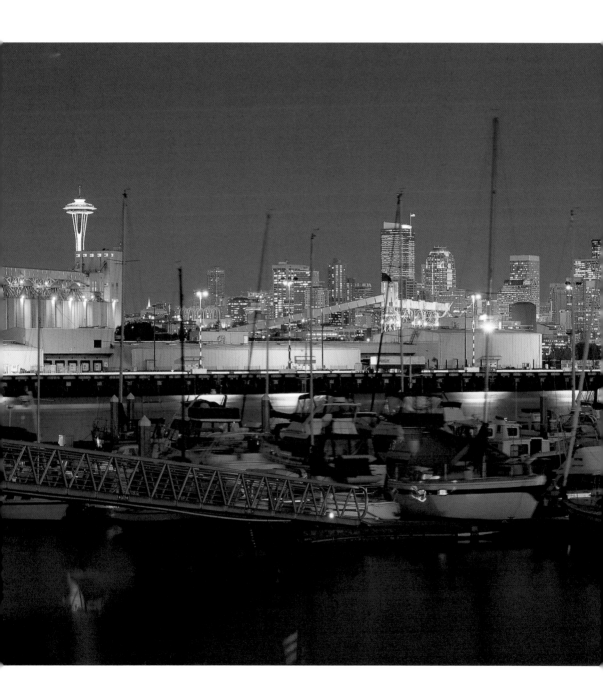

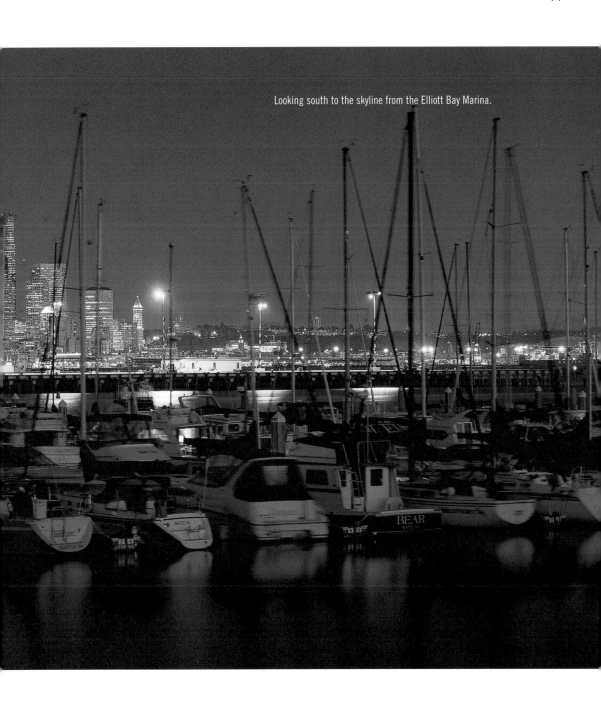

Looking south to the skyline from the Elliott Bay Marina.

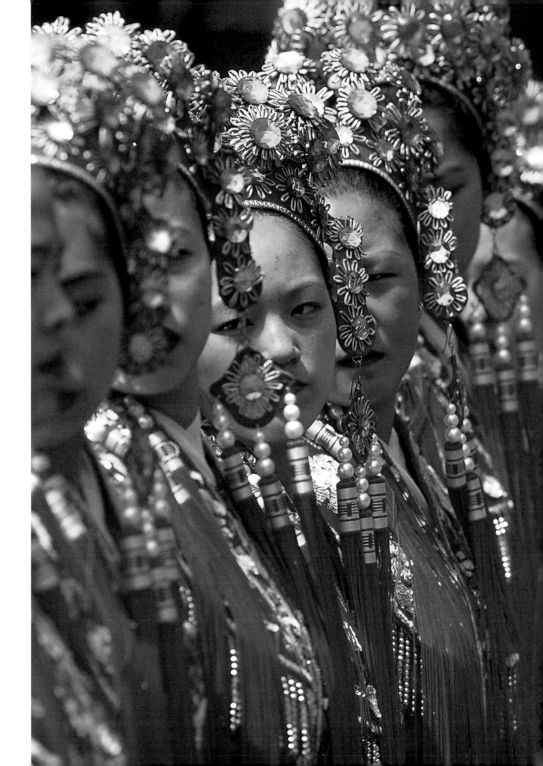

Seattle Chinese Community Girls' Drill Team.

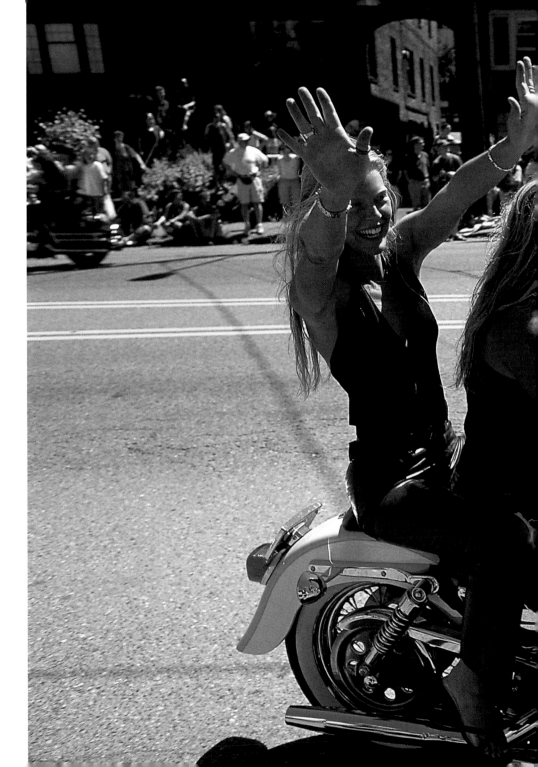

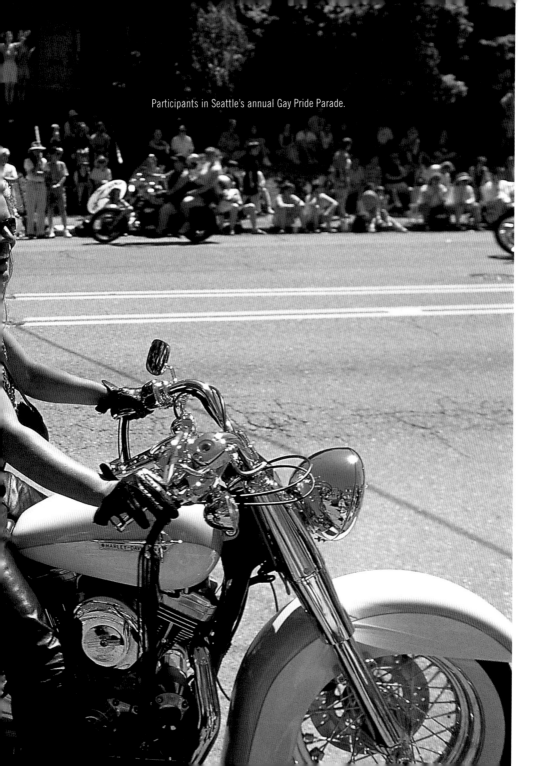

Participants in Seattle's annual Gay Pride Parade.

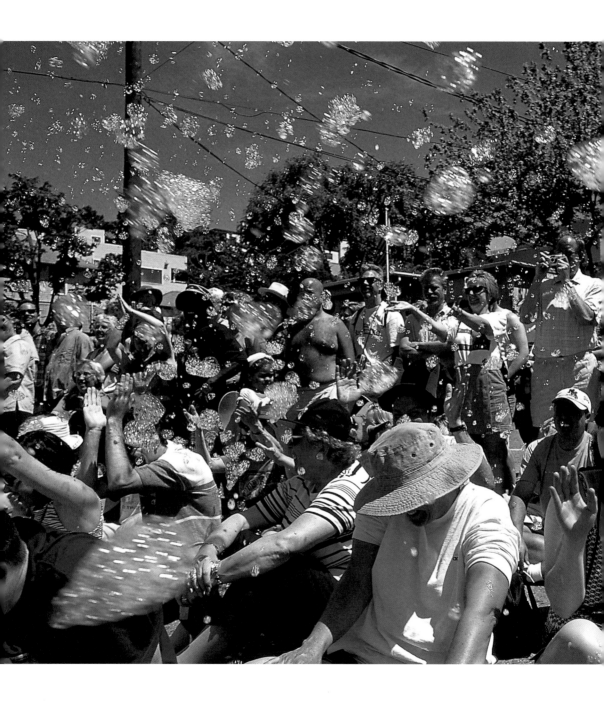

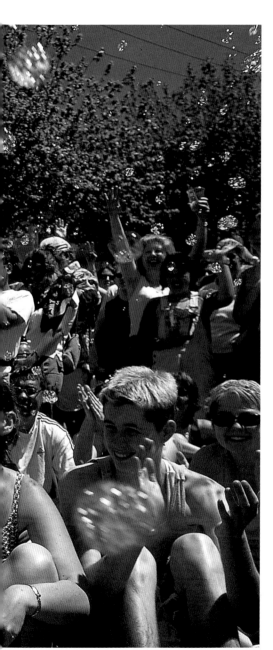

Left and below: Spectators and revelers at the Fremont Solstice Parade.

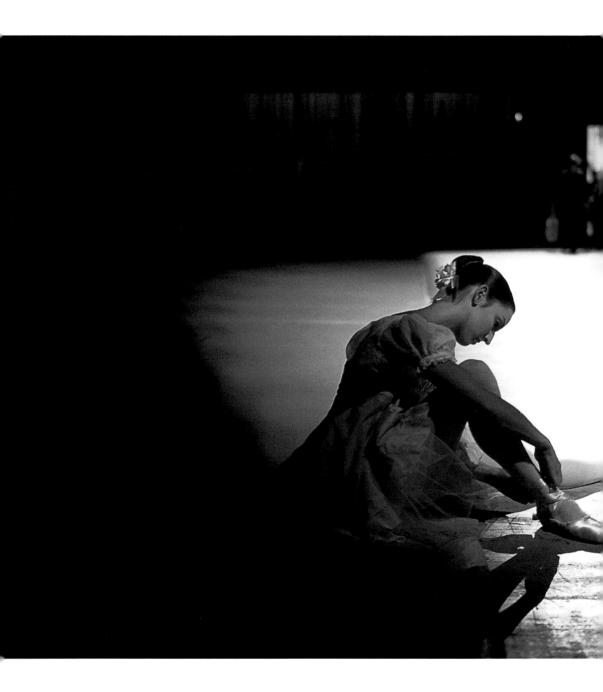

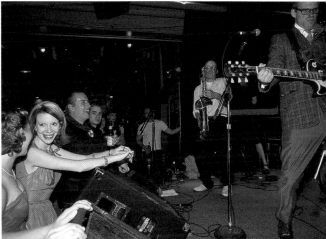

Left: Backstage before a performance of the Pacific Northwest Ballet.

Above: Rockabilly band plays live at the Tractor Tavern in Ballard.

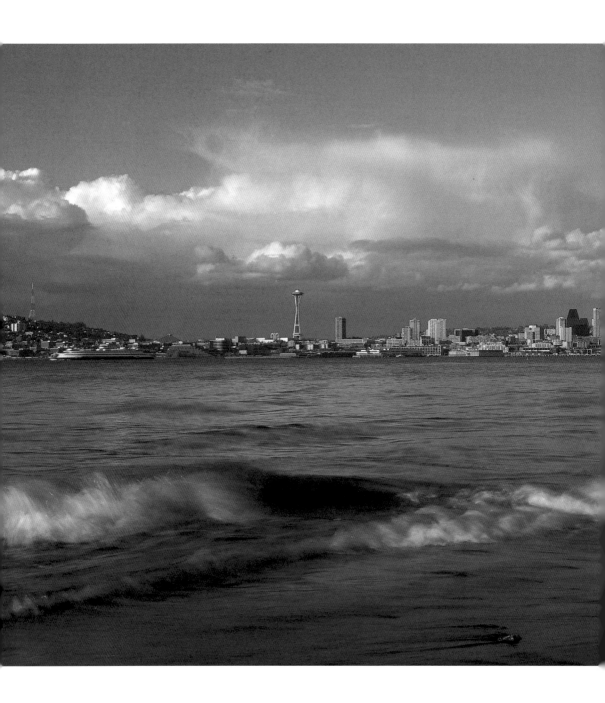

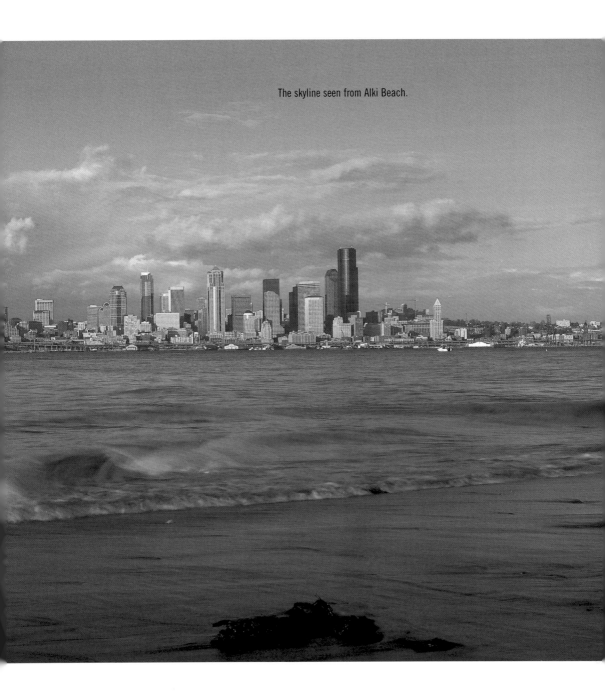

The skyline seen from Alki Beach.

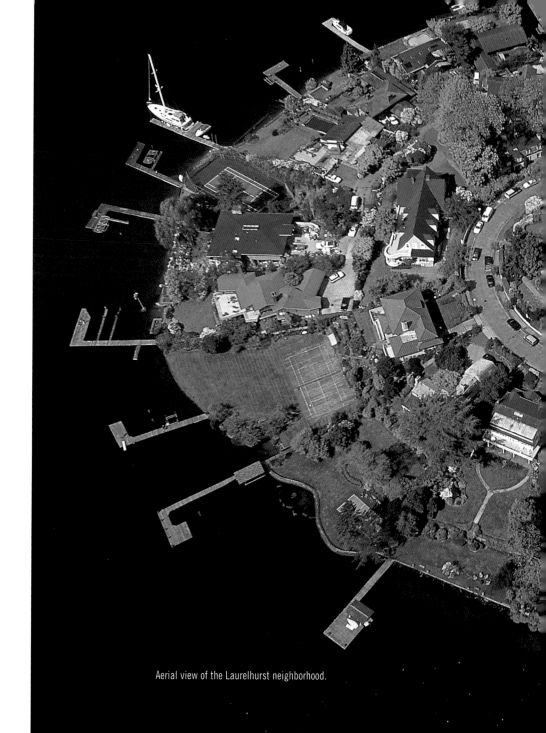

Aerial view of the Laurelhurst neighborhood.

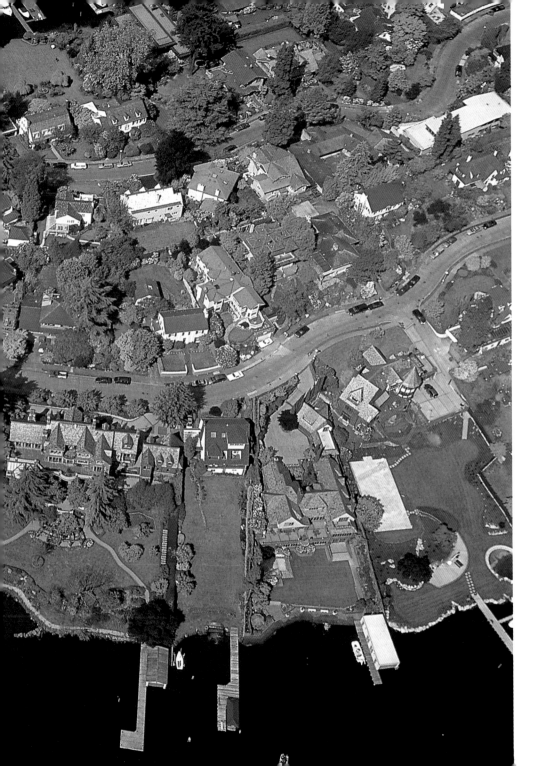

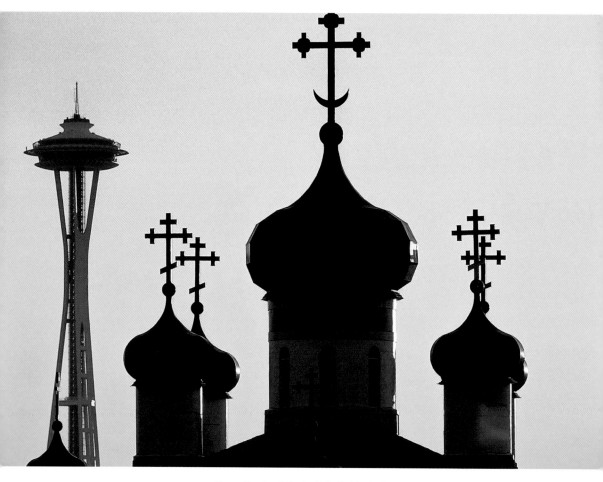

Above: Russian Orthodox Cathedral in the Denny Regrade neighborhood.

Right: Houseboats on Lake Union.

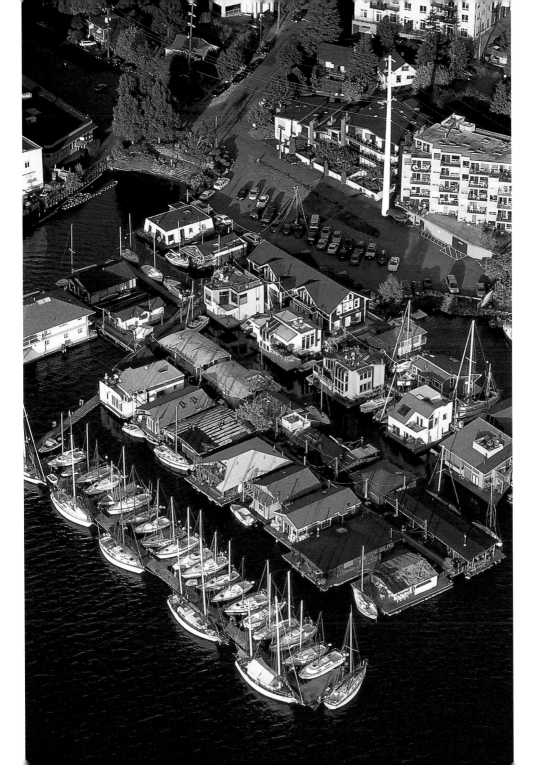

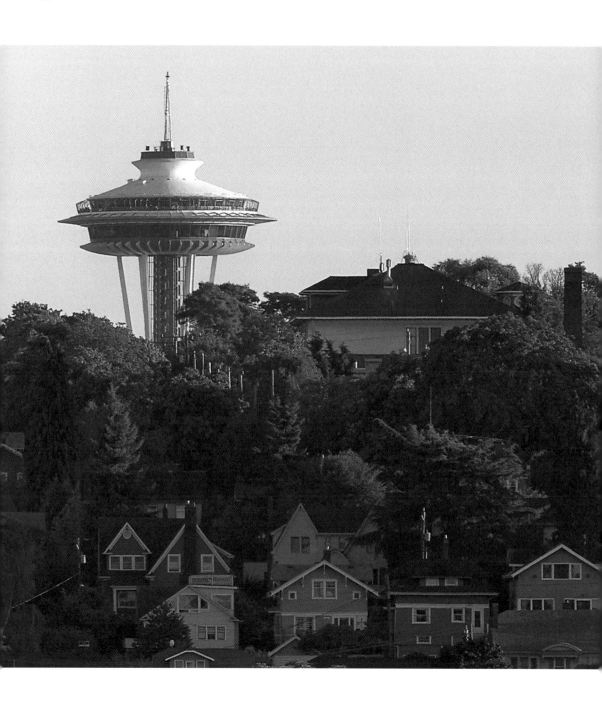

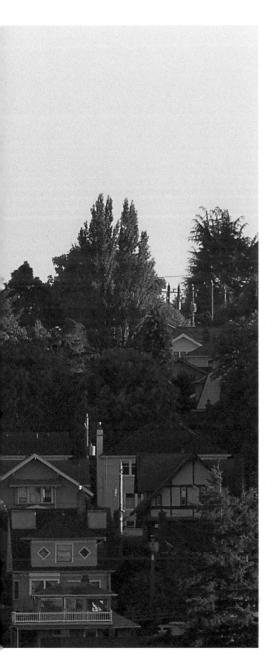

Left and below: Queen Anne Hill neighborhood.

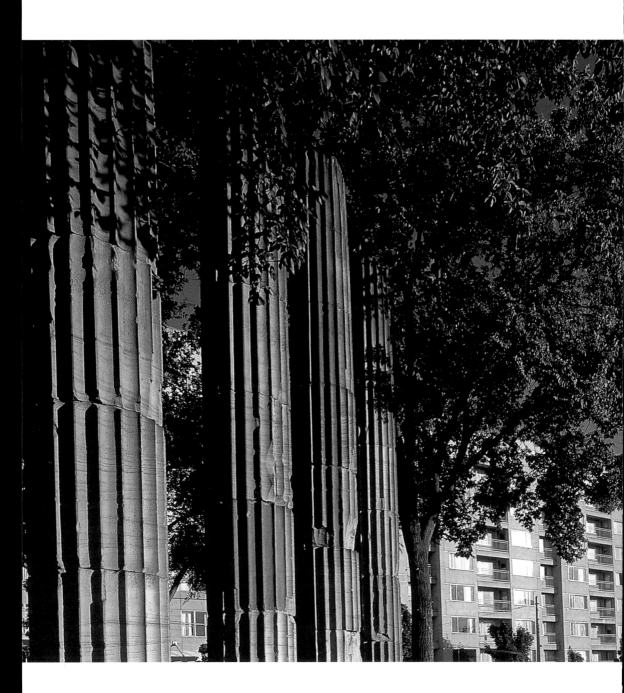

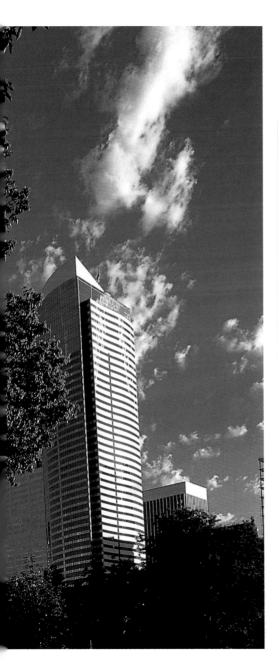

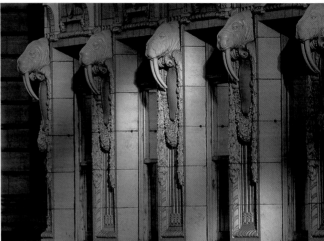

Left: Four Columns Park near downtown.

Above: Walrus gargoyles on the Arctic Club Building.

The Virginia Inn, a Belltown institution.

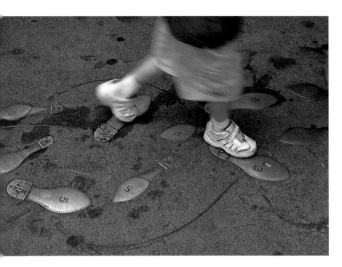

Top: Brass dance steps set in the sidewalk on Broadway in Capitol Hill.

Above: St. Clouds restaurant in Madrona.

Right: Pioneer Square totem pole.

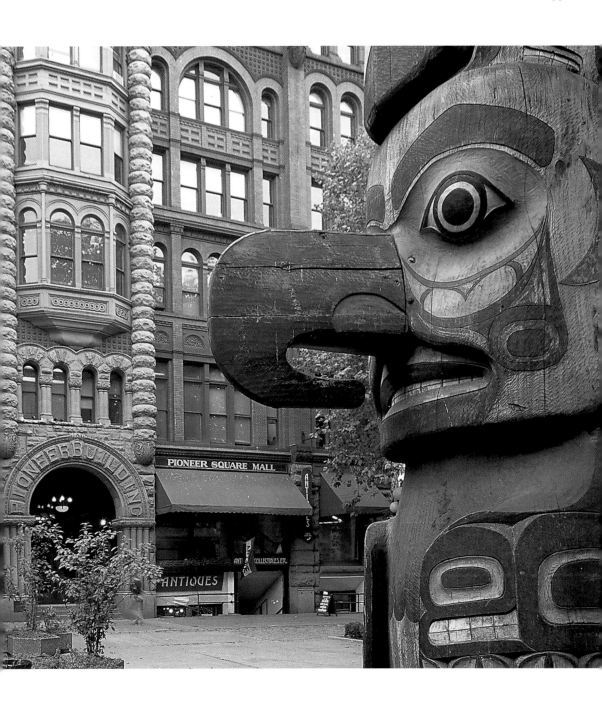

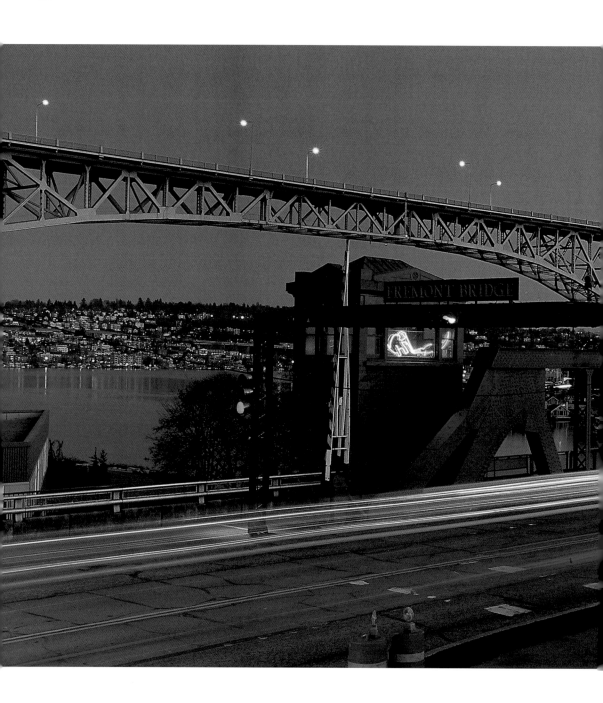

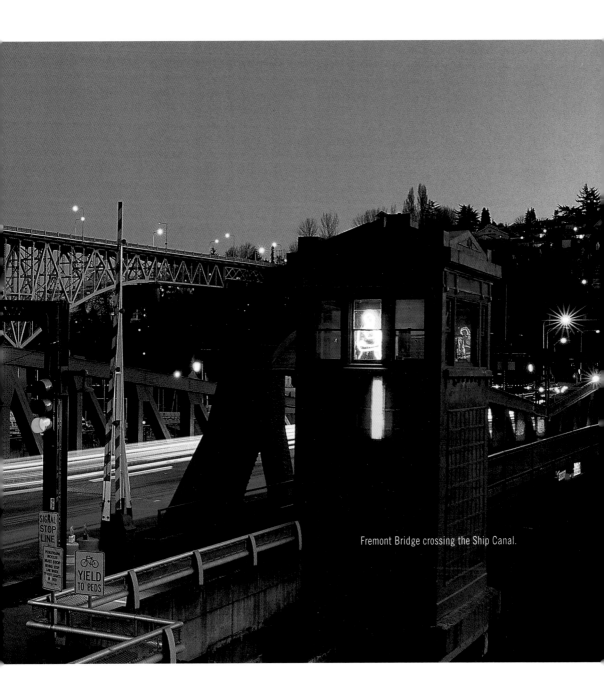

Fremont Bridge crossing the Ship Canal.

SIGNAL
STOP
LINE

PEDESTRIANS
BICYCLIST
MUST STOP
BEHIND STOP
LINE WHEN
TRAFFIC SIGNAL IS
OR RED

YIELD
TO PEDS

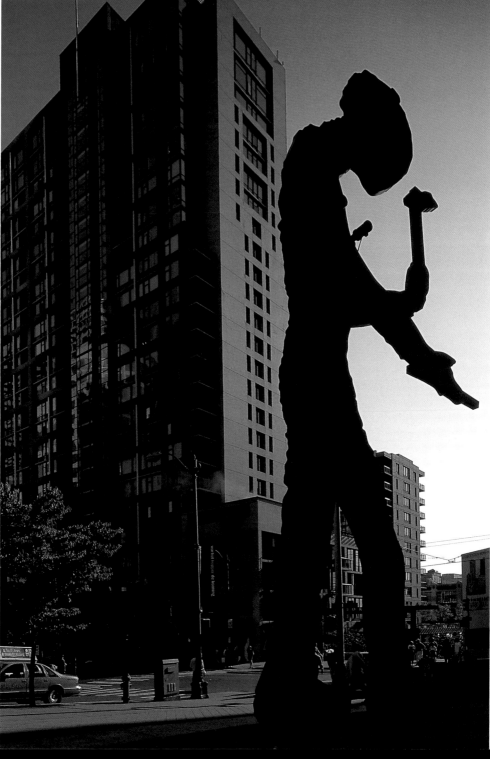

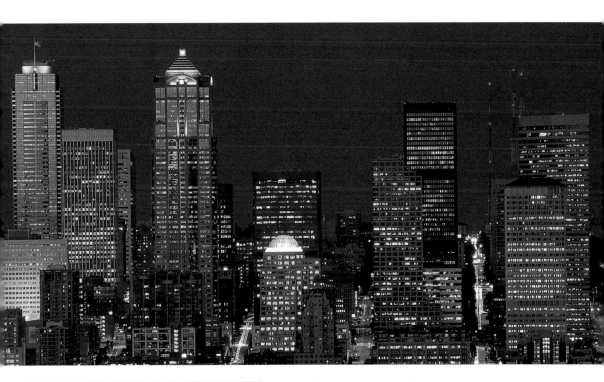

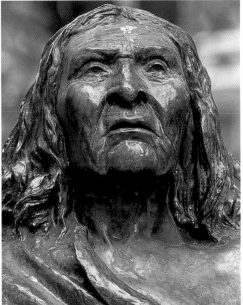

Far left: "Hammering Man," the 48-foot-tall kinetic sculpture by Jonathan Borofsky, stands in front of the Seattle Art Museum.

Above: The downtown skyline from West Seattle.

Left: Sculpture of Chief Seattle.

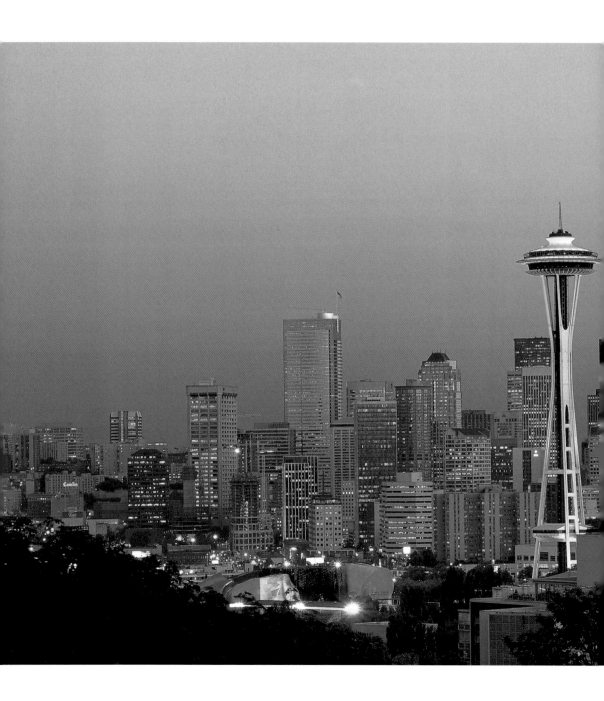

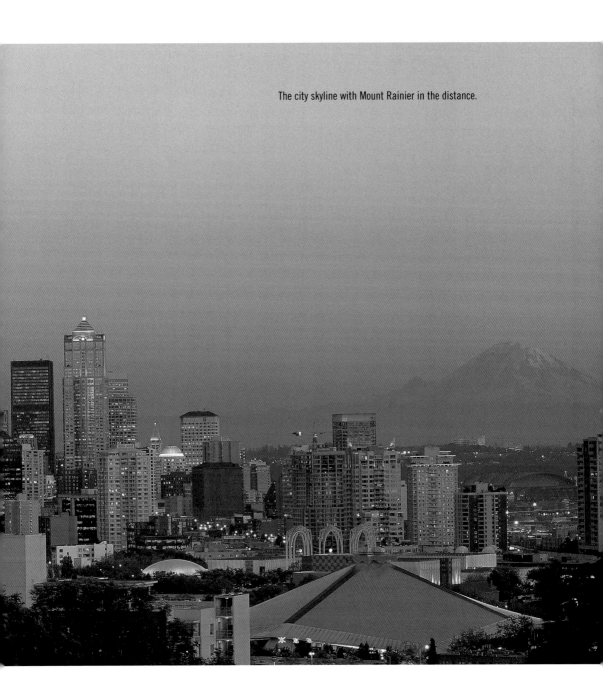

The city skyline with Mount Rainier in the distance.

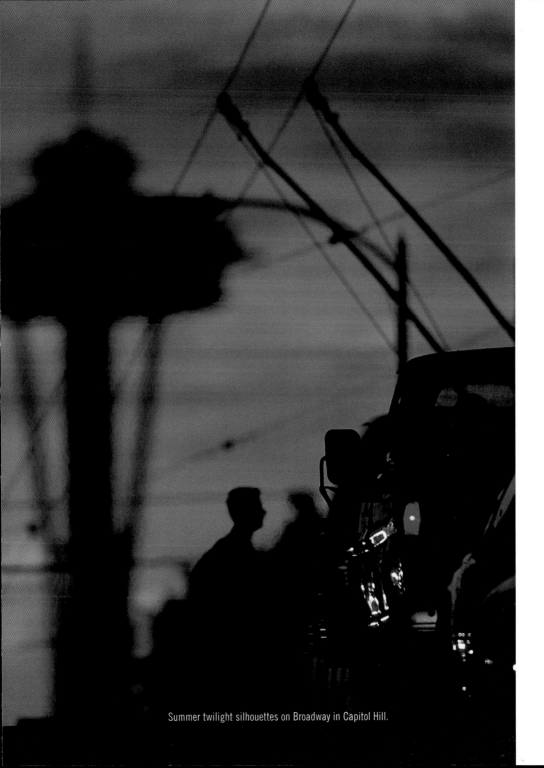

Summer twilight silhouettes on Broadway in Capitol Hill.

ABOUT THE AUTHORS

For nearly twenty years, Paul Souders has traveled across all seven continents. But for the better part of the last decade, he has called Seattle home. Paul's work has appeared in a wide variety of magazines and books, and his images are also represented by Getty Images and Corbis around the world. His website offers a mix of photography and dark humor at www.worldfoto.com.

Bill Radke moved to the Seattle area in 1981 as a high school junior. He has been a host on Seattle's National Public Radio station KUOW since 1991. He's also a columnist for the *Seattle Post-Intelligencer,* a stand-up comedian, and a corporate speaker.